OXFORD
WATERWAYS
THROUGH TIME
Nancy Hood

AMBERLEY PUBLISHING

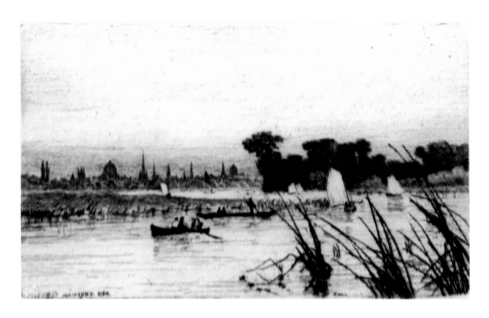

Oxford from the Upper River
Etching by Wilfred Ball, *c.* 1880. A scene fast disappearing as new housing crowds the skyline.

First published 2012

Amberley Publishing
The Hill, Stroud, Gloucestershire, GL5 4EP
www.amberley-books.com

Copyright © Nancy Hood, 2012

The right of Nancy Hood to be identified as the
Author of this work has been asserted in accordance with
the Copyrights, Designs and Patents Act 1988.

ISBN 978 1 4456 1200 3 (print)
ISBN 978 1 4456 1292 8 (ebook)

British Library Cataloguing in Publication Data.
A catalogue record for this book is available from the
British Library.

Typesetting by Amberley Publishing.
Printed in Great Britain.

Introduction

The very name of Oxford, the Saxon Oxenaforda, underlines the importance of its waterways. A ford allowed a river crossing of the Thames, and early on a bridge enabled travel over the marshy floodplain to the south. It is thought the ford may have been on a prehistoric or Roman trade or drover route from north to south – prehistoric mounds and burials are to be found all over Oxford, but no dwellings. The sand and gravels brought down by the Thames from the Cotswolds after the last glaciers melted supplied the Romans with raw materials for their pottery industry. The distinctive, high-quality pottery was traded all over the Empire.

Oxford enters history with the Saxons. The Thames provided a border between the kingdoms of Wessex and Mercia, and possibly a trade route. Frideswide, a Mercian princess, founded a monastery near the ford as early as the eighth century and the town grew up at its gates. The location proved favourable. Oxford expanded and became important enough to be defended against the Danes, first as a Mercian stronghold and later under Alfred the Great.

The Normans appreciated the strategic site on the Thames and in 1071 they strengthened the Saxon defences with a timber tower upon a motte, or mound, followed by an adjacent stone keep, sturdy walls, towers and outer bailey. The Thames and its boggy western floodplain provided one line of defence, and the Castle Mill supplied water for the moat.

Medieval Oxford became filled with monasteries and abbeys. Water from the rivers drove their mills, soaked rushes and osiers for baskets and hurdles, softened flax for linen, washed their clothes and flushed their latrines. Fishermen plied the rivers in punts, setting traps for eels with which they supplied the households and colleges. Tanners, parchment-makers, papermakers and brewers harnessed the rivers for their trades, as did the monastic and manorial millers.

Mills were to be found on every braided channel of the Thames and on the Cherwell. However, they had declined to around half a dozen by the seventeenth century. A waterwheel drove the machinery at Morrell's Lion Brewery in St Thomas's until 1880 and Hampton Gay on the Cherwell boasted a water-powered paper mill until 1887. Wolvercote and Sandford paper mills supplied the University until well into the twentieth century. North of the city many mills operated between Wolvercote and Banbury on the Cherwell, near the line of the Oxford Canal, such as the Heyfords, Kirtlington and Somerton.

The waterways also supplied the city with goods from sources in the countryside: corn, malt, timber and stone. Small barges could navigate the Upper Thames as far as Lechlade. Beyond

the river's navigation, goods were carried by pack mule or wagon. We know how crucial river trade was because at Oxford during the Civil War Charles I complained that the Roundheads had blocked his supply route on the Thames between Wallingford and Eynsham. His solution was to clear the Cherwell of its mills, bridges and weirs to bypass the Thames, but this work was not carried out.

The barging trade flourished again after the Civil War and the Thames navigation northwards was improved. In 1790 the Oxford Canal pierced the centre of the city, with a basin and two wharves right next to the castle moat. Industrial goods from the north and Midlands, particularly coal, could now reach the towns of the south via the Birmingham, Coventry and Oxford Canals. It was a new, watery lifeline providing fuel at reasonable prices, and business boomed, reaching a peak in 1830, and so did Oxford's waterways communities.

In the first national census of 1841, the three Fisher Rows, for instance, had a population of 235 in the growing St Thomas's parish. Together with those at Hythe Bridge Wharf, there were eighteen canal boatmen, six fishermen, and three bargemen, demonstrating the growing strength of the canal trade over the traditional barging business. In 1851 there were thirty-four canal boatmen but only two bargemen. There were also five 'boatmen wives' heading households while the men ran canal boats and four men had reverted to fishing for a living.

This way of life changed with the coming of the railroad in 1844, which meant food, coal and other goods could be brought into Oxford even faster. The mainstay of the barge and canal trades was on the verge of collapse, even after the Thames Commissioners reduced tolls by 20 per cent in order to compete with the railways.

What was left for the river and the canal in the twentieth century, when railways and the motor car superseded waterborne transport, and steam triumphed over water power? Both water and steam-powered mills frequently caught fire, and often it was not cost-effective to rebuild them. Iffley Mill and Hinksey Mill fell to this fate. Coal still came down the canal after the wharf at Hythe Bridge had been sold off, but to the wharf at Juxon Street, Jericho, where it was carted to Morrell's Brewery. Here some families still lived a difficult life on narrowboats, with a lack of medical care and interrupted schooling for their children. Rose Skinner, the last of the women who shoveled coal at the wharf, died in June 2012, aged eighty-seven.

With the decline of commercial river traffic, use for pleasure filled the gap. In Oxford, many bargemen made a living running pleasure boats from Folly Bridge, and at first watermen could enter rowing matches along with undergraduates as the sport grew. University boat races and regattas such as Henley provided employment for the watermen, so there was some life after barging. Colleges kept splendid barges from which to view the University boat races. Upriver, the Fisher Row bargemen, fishermen and boatmen were drawn to a different sport – punting. Punt races became a feature of Oxford City's Regatta, established in 1841, and punt races for watermen were started the following year.

By the early twentieth century, many families had left the canalside and Fisher Row to take up employment and housing elsewhere. The canal wharf had been sold to William Morris, Lord Nuffield, and after the Second World War Nuffield College rose in its stead. The Oxford Canal survived though, north of Hythe Bridge, thanks to repeated local campaigns, and now has moorings for local narrowboat residents and pleasure craft, a different lifeline to the city.

Acknowledgements

The historic photographs have largely come from the History Centre, St Luke's church, Oxford, under the Images and Voices collection. The staff were, as usual, incredibly helpful in supplying the digitised images. The author would like to acknowledge the Estate of Chiang Yee for the print of Port Meadow from *The Silent Traveller in Oxford* (1946), and David Meeks for permission to include *The Thames in Flood*. Jeremy Daniel, a long-standing postcard dealer of Oxford, now operating on the internet, supplied a number of postcards and has kindly allowed their reproduction in return for this acknowledgement. The remaining prints and many of the postcards have been collected privately from local dealers and eBay. Matt Hood has again explored the Cherwell and Port Meadow to photograph some characteristic scenes to order. The late Dr Mary Prior's book, *Fisher Row: fishermen, bargemen, and canal boatmen in Oxford 1500–1900*, now reprinted, was the main source of information on the inhabitants of Fisher Row and the life of the canal people and bargemen. She kindly made available the three paintings of Fisher Row by R. Murdoch Wright (1909). Mark Davies' book, *A Towpath Walk in Oxford*, has much more information on the canal and the stories attached to it that would interest the reader, and it should certainly be the guide for anyone walking the towpath in Oxford. *The Oxford Canal* by Hugh J. Compton was also indispensible and needs only to be brought up to date with the developments to the canalside and the canal's renewed lease of life since the book's publication in 1976. Local people have shared information; friends and my husband have walked sections of the canal with me, occasionally getting a lift on a narrowboat, and making light of getting to know 'the Oxford' first hand. I decided to include all of 'the Oxford' in Oxfordshire because it has survived, after many vicissitudes, through time.

The Castle Mill Stream and Fisher Row

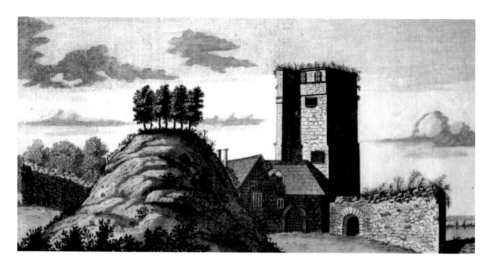

The Castle and Prison

The remains of the Norman motte, St George's Tower and the castle buildings as they appeared in 1769; the walls had been in ruins since the slighting of the castle after the Civil War. The ruined wall next to the mound today is a section of Oxford Prison's wall, left to demarcate the prison boundary when the site was transformed into a hotel, restaurant and heritage complex after 1996. The crown of trees was a decorative element often forced onto ancient mounds and monuments, and is a threat to the underlying archaeology, as well as possibly contributing to the occasional slippage of the mound material downslope.

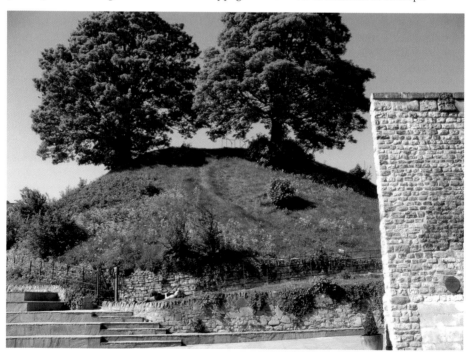

Castle Mill

The mill existed even before the castle, and its mill had been cut from the main river channel of the Thames in Saxon times. It was recorded in the Domesday survey and was held be the Saxon Alfgar. A fisherman named Vluuius mentioned there may also have lived along this part of the river. The mill was sacrificed to a road widening scheme in 1929, and only the base of the wheel-bed can be seen, but it is still a picturesque sight around St George's Tower. The new student housing for St Peter's College reflects the gables of the early building. This famous view is an aquatint from R. Ackermann's *History of the University of Oxford* (1814).

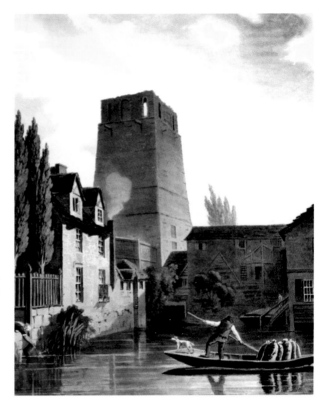

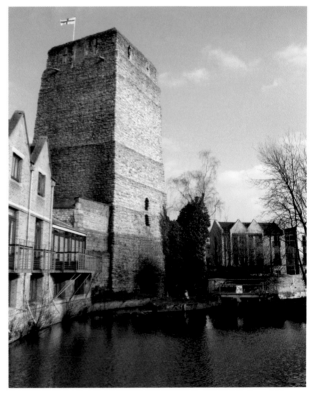

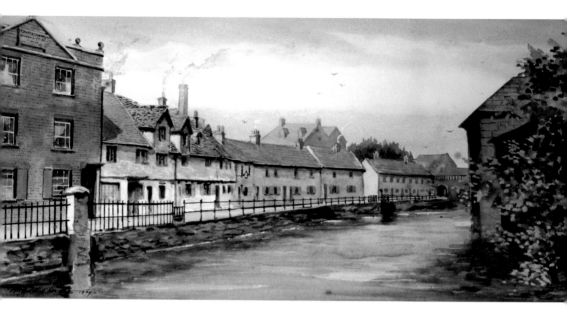

Lower Fisher Row

Lower Fisher Row's fishermen set traps early on next to the mill. This row of fifteenth- and sixteenth-century cottages along the mill stream had the most favoured position. The little lock in the gap between the cottages at the upper end opened onto Back Stream, or the Wareham Stream, and the bank that is now Fisher Row was known as the Wareham Bank. The red-brick eighteenth-century buildings on the end were built by Edward Tawney, who was from a family of bargemasters, later brewers and bankers – one as his house and the other as endowed almshouses. They are all that is left of Lower Fisher Row's connection with river trades; the cottages were pulled down in 1954. This watercolour by R. Murdoch Wright, of around 1909, used to hang in the Nags Head pub on the corner of Hythe Bridge Street, along with those of Middle and Upper Fisher Row.

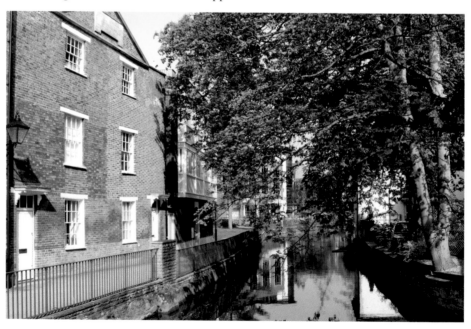

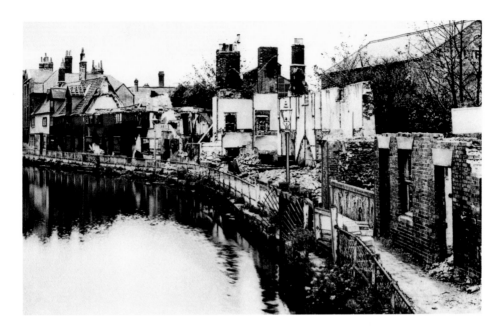

Stream Edge

As the living from the river declined – there were too many fishermen, barges ceded trade to canal boats, then to motor transport – the communities along the mill stream found it difficult to sustain their way of life. The local breweries provided more work, as did carrying coal for the canal boats and working for the railways. After the Oxford Canal Company ceased trading and the wharf was sold off the cottages fell empty. The residents were rehoused elsewhere. Following a long period of dereliction, Lower and Middle Fisher Row were pulled down in 1954, and the whole area was more or less deserted. In 2004/05, a new development of apartments called the Stream Edge, built by local builders Kingerlee, took their place on Lower Fisher Row. Sensitively, the footprint of the houses was left as gardens and the new buildings were set on their former back gardens.

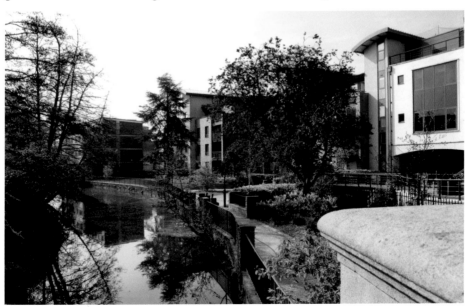

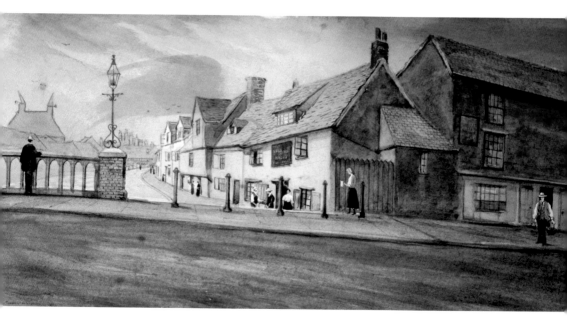

Middle Fisher Row

Middle Fisher Row lay between Pacey's Bridge to the south and Hythe Bridge, which was rebuilt in 1861. Hythe is the Saxon word for wharf, and both Middle and Upper Fisher Row sported wharves, long before the canal and its coal wharves pierced through the remains of the castle bailey towards the mound. The Nag's Head pub on the corner catered for bargemen, and their horses in stabling behind. When the pub was rebuilt in 1939, the occasion on which these watercolours were taken down from the walls, no stabling was provided and customers entered from the road, not from barges on the mill stream. Watercolour by R. Murdoch Wright, 1909, and engraving by Joseph Skelton, early eighteenth century.

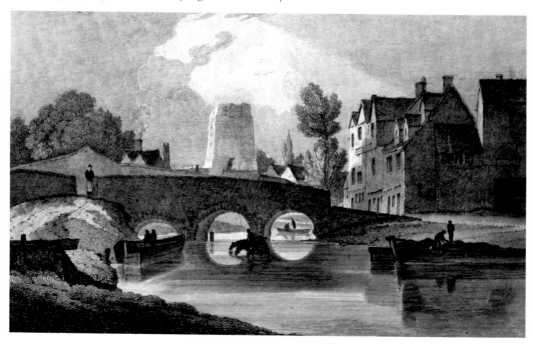

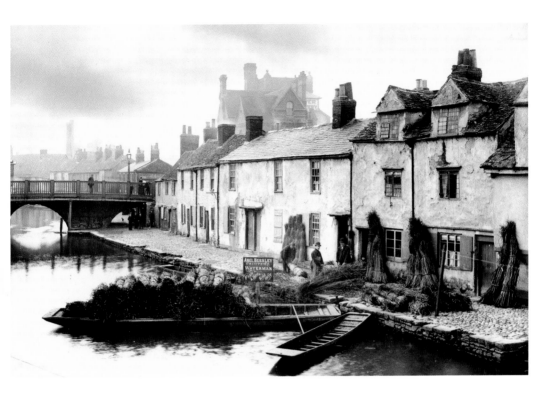

Abel Beesley

The fisherman Abel Beesley ran barges, and also a business cutting osier reeds and willows for making traps, baskets, hurdles and handles, right up to the 1920s, from his wharf on 28 Middle Fisher Row. The fishermen's cottages often flooded, and perhaps the last inhabitants were glad to be rehoused after they were pulled down in 1954. Middle Fisher Row has been left as a small park on the mill stream.

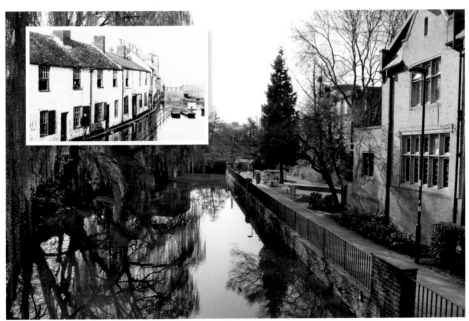

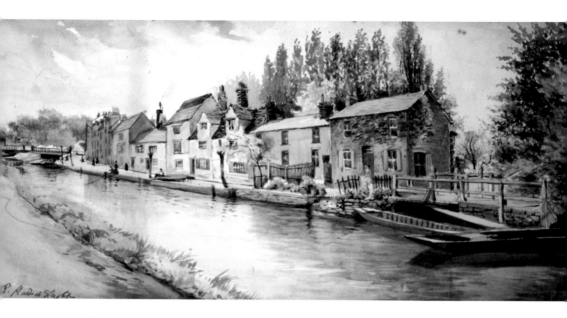

Upper Fisher Row

Upper Fisher Row, because it was higher than its brothers, did not flood as badly, and the houses there were more substantial. Instead of deteriorating, they were rebuilt in the early nineteenth century, and those late Victorian and Edwardian terraced houses are still occupied. Some council houses and 1930s duplexes also fill the gaps left by the seventeenth-century cottages. Upper Fisher Row was best placed to take advantage of the wharves for the canal as well as continuing to run with the river using the Castle Mill Stream. It was not cut off from navigation when Pacey's Bridge was widened for lower traffic, as Lower Fisher Row was. The mill stream and the canal ran side by side as far as Walton Well Road. Watercolour by R. Murdoch Wright, 1909.

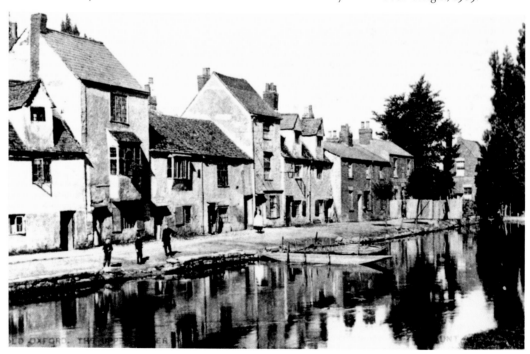

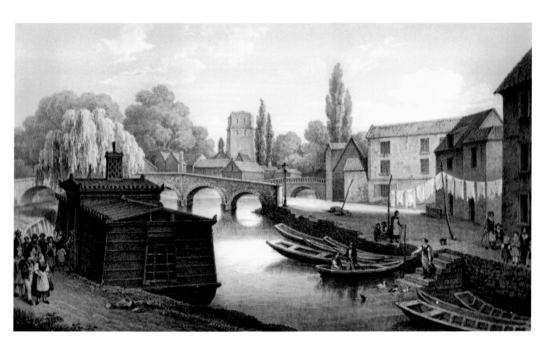

The Floating Chapel

The Boatman's Floating Chapel was moored opposite the wharf on Upper Fisher Row. This lithograph by H. Mutzel after Carl Rundt (*c*. 1848) depicts daily life in the area, with punts, washing hanging out and, unusually, adults and children about, showing their manner of dress in some detail. The chapel was built and donated to the boating folk by Henry Ward, coal merchant and boatbuilder at the wharf further along the canal in Jericho. It was moored there from 1839 until it sank in 1868.

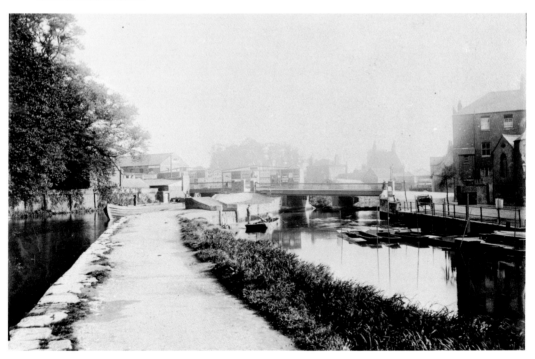

The Beesleys and Bossoms

The Beesley family of bargemen and fishermen had come to occupy most of the tenancies of Upper Fisher Row. They customarily encroached on waste ground at the top of the row, provoking the other family of boatmen, the Bossoms. A battle ensued when the Bossoms destroyed the crops and trees planted there, but the City found for the Beesleys and they rented the ground legally thereafter. Here they established the osier works. The Lasher (*inset*), the sluice at the end of Upper Fisher Row, marked the limit of their overlordship.

Rewley Abbey

The ruins of the thirteenth-century Rewley Abbey were more substantial at the time the illustrations for the *Memorials of Oxford* were done in the mid-nineteenth century. This single arch and section of wall is all that remains of the abbey wall along the mill stream. The abbey was dissolved along with Oseney Abbey and thousands of others in the 1530s. The new houses that have been built on the abbey land, which subsequently belonged to the railway, can just be glimpsed through the arch.

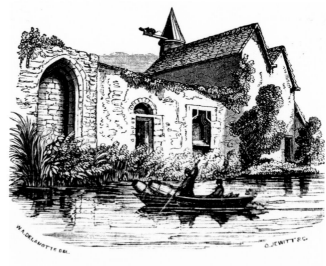

RUINS OF REWLEY ABBEY.

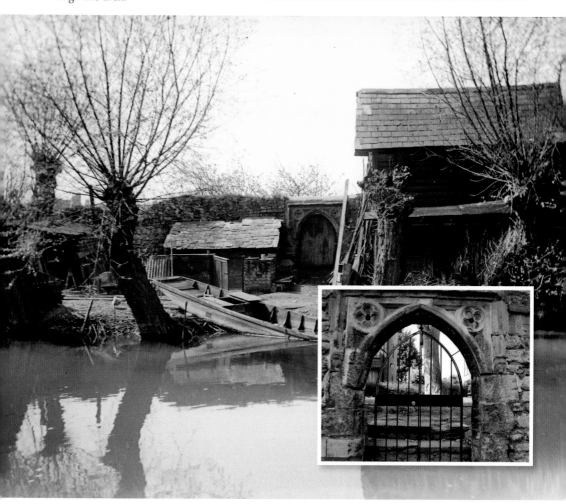

The Thames from Folly Bridge to Wolvercote

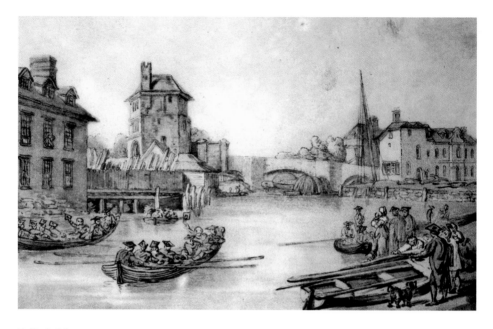

Folly Bridge

Folly Bridge, the Grandpont, is the southern gateway to Oxford. The confluence of the two rivers, the Isis and the Cherwell, and the marshy approach were deemed an adequate defence, and the crossing was defended by only a gateway in the Middle Ages. 'Friar Bacon's Study', where the alchemist was said to have worked in the thirteenth century, stood on the gateway until the road and bridge were widened in 1779. This humorous late eighteenth-century print is by Thomas Rowlandson.

Oseney Abbey

Medieval Oxford flourished through a plethora of abbeys. Oseney Abbey was one of the greatest. It was founded by Robert d'Oilly the younger at the instigation of his wife Edith as a penance for her sins as a royal mistress to Henry I. The abbey developed the suburb of St Thomas between its lands and Oxford Castle, which prospered with the cloth, leather and milling trades. The abbey church nearly became Oxford's cathedral after the Dissolution in 1539, but instead became a huge quarry of building stone. Oseney Town is now a small island within Oxford.

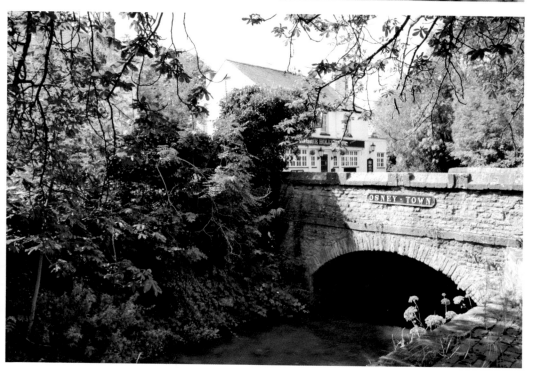

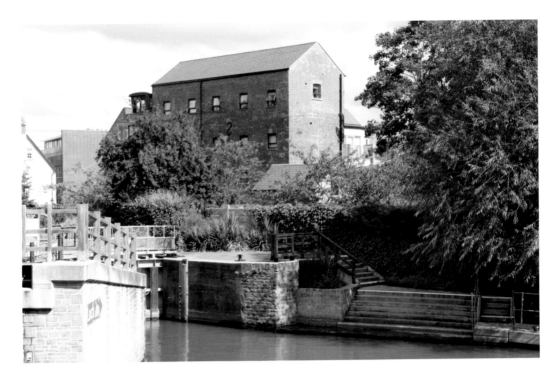

Oseney Mill

Oseney Mill occupies the site of the ancient abbey mill, along with a tiny ruined outbuilding, and enjoys a prominent position on the cut made to the Isis in 1790 to enable barges to move more freely between the Oxford Canal and the river. Henry Taunt photographed it in the winter of 1885. Fire destroyed it in 1945 and it was left derelict until plans to restore it into apartments were put forward in 2004. After years in scaffolding, in 2012 the mill imposes itself once more on Oseney Lock, drawing power from the weir and using ground source heat.

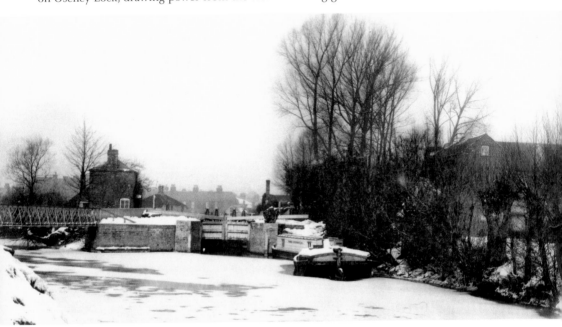

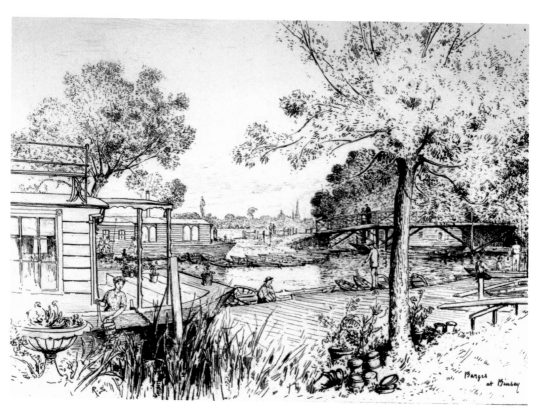

Medley

Early in the nineteenth century, at Medley on the Thames, a branch of the Bossom family established themselves as fishermen and watermen, and became boatbuilders; this may have been the result of a feud with the Beesleys, a feud that continued well into the century. This charming illustration from *Summer Days on the Thames*, by A. J. Church (*c.* 1886) shows a lively boating business, and perhaps some families living on the barges.

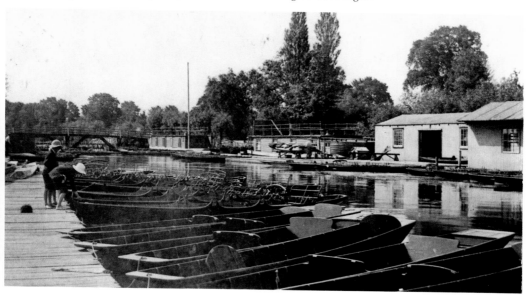

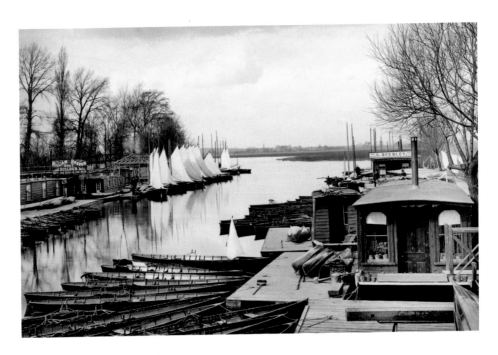

The Rainbow Bridge, Medley

Here, in 1895, the Beesley boatyard on the right faces the Bossom fleet on the left. As fishing and the barge trade declined, the watermen took to hiring out pleasure boats and punts and running trips up the river to Godstow. By the Rainbow Bridge at Medley, a lone punt reminds us of the former work of the boatmen, but otherwise the scene is little changed from Henry Taunt's photograph of 1903 (*inset*).

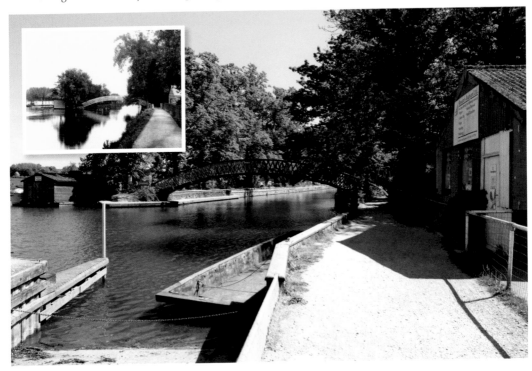

Treacle Well and Binsey

A short footpath from Medley leads to the Perch, a sixteenth- or seventeenth-century pub in the hamlet of Binsey, seen here during floods in 1924. Lewis Carroll led Alice Lidell and her sisters to the 'treacle well' next to Binsey church on their legendary trip up the Thames to Godstow in 1862, which saw the telling of *Alice's Adventures in Wonderland*. The spring had miraculous properties as a cure in the Middle Ages, from which 'treacle' is derived. The isolated pub is in fact on a well-trodden medieval route between Godstow and Oseney Abbeys.

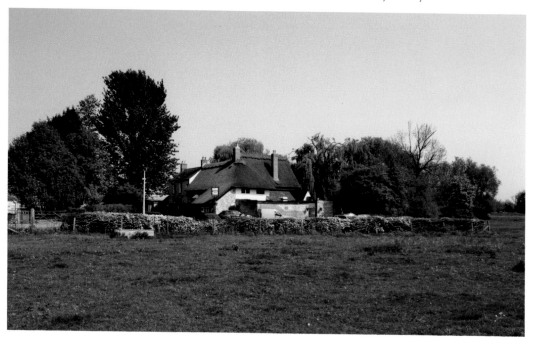

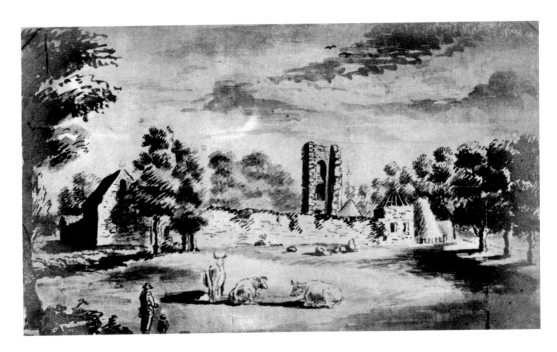

Godstow Abbey

A short punt from Medley takes you to the ruins of Godstow Abbey, another layover in the summer jaunt of Alice Lidell, where they would have tea. The little abbey, founded in 1133, is the burial place of 'Fair Rosamund', the mistress of Henry II. Her tomb near the high altar of the church was a place of reverence for local people, but the bishop disapproved of this love of the harlot and had the tomb removed to the nuns' cemetery, where it was destroyed during the Dissolution of the Monasteries. Henry Taunt recorded this drawing of the ruins as they stood around 1748.

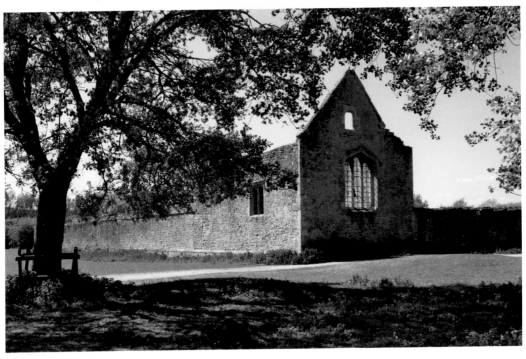

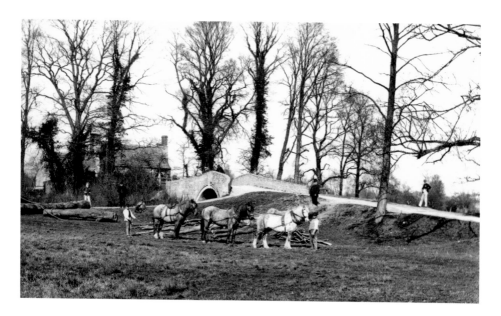

Fishing at Godstow

Godstow's old bridge, with the Trout in the distance, is seen in a Henry Taunt photograph from around 1880. Fishing by the weir, around 1895, has produced a good catch – a large trout perhaps? By this time, fishing was more a leisure sport, but the hardy fishermen of Fisher Row could always find a way to supplement their trade by working the river. This does look more exciting than sitting on the towpath in the cold under an umbrella. The fishermen were also adept at punting, and racing had become a great sport on the river near Medley.

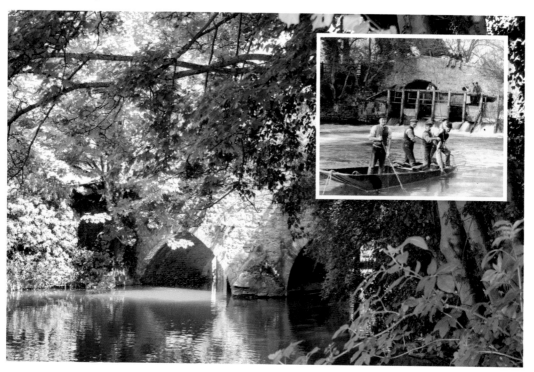

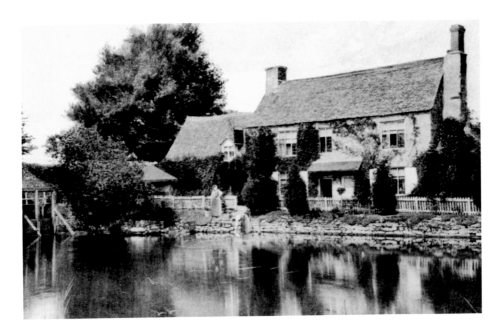

The Trout Inn

The seventeenth-century Trout Inn strides the weir at the top of Port Meadow, reached by a series of old bridges that cross the various braided channels of the Thames and then Wolvercote mill stream. An inn was recorded here in the twelfth century. Popular in the winter for its stone-flagged bar and open fires, and in the summer for its terrace by the weir, the pub has expanded enormously to cope with its fame. The peacocks add delight too, as well as demanding their share of the grub.

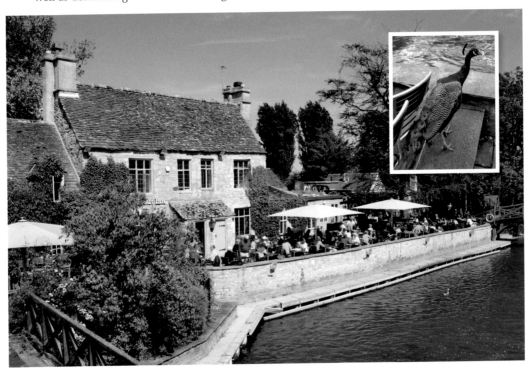

Wolvercote

The tiny village of Wolvercote on the northern edge of Port Meadow must have felt overwhelmed by the industrial revolution on its doorstep – from 1720 the paper mill ran its wooden waterwheels from the Wolvercote mill stream, and then in 1789 the canal cut the village in half. From 1811, the Duke's Cut enabled canal boats to bring coal to the mill, and the power changed to thundery steam. In 1846, the Oxford to Rugby railway line joined the route of the canal, and four years later the Buckinghamshire Railway was driven through a separate cutting. The peaceful riverside settlement must then have reverberated with noise. Now the bypass adds its hum.

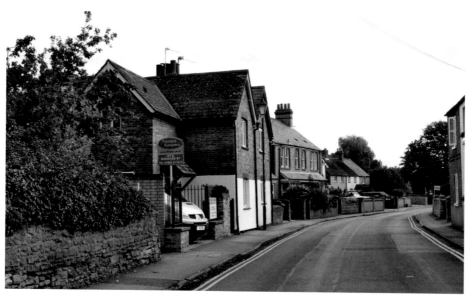

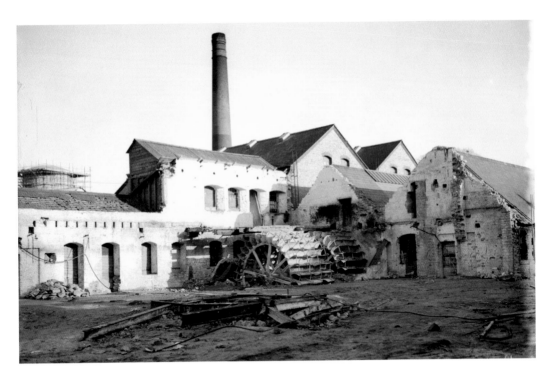

Paper Mill, Wolvercote

Wolvercote Paper Mill was a big employer in the village until it closed in 1998. It was first owned by the Duke of Marlborough, and later leased to William Jackson, who produced *Jackson's Oxford Journal*. The mill specialised in fine Bible paper and supplies to Oxford University Press. The buildings were demolished in 2004, leaving only the mill house and an unsightly cordoned off site destined eventually for housing.

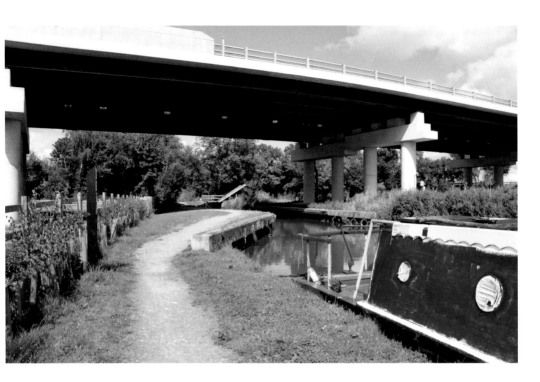

The Plough, Wolvercote Green

The canal passes the Plough pub on Wolvercote green where there is a small reservoir and formerly a wharf. Wolvercote Lock, and the railway running alongside it, are overpassed by this bridge, which again threatens to divide the village. Its weight-bearing capacity is now limited to one-way traffic, and lorries may not be able to use it for much longer, unless it is rebuilt. The early nineteenth-century pub is the newest of three, in addition to the Trout, in the village. It served the canal boatmen as well as the locals.

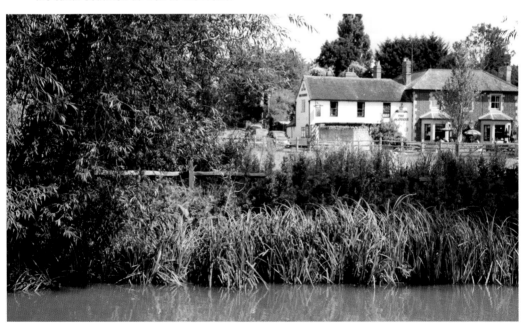

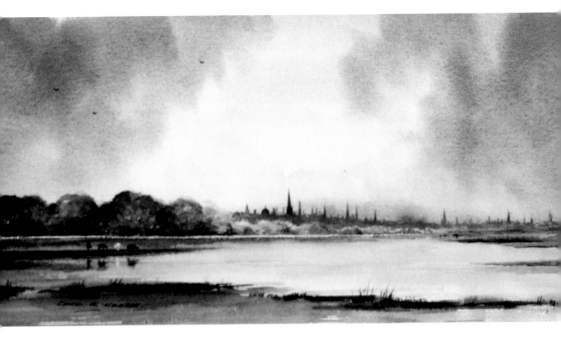

Port Meadow

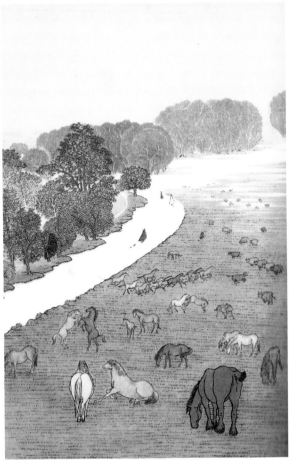

Land held by freemen in common was mentioned in the Domesday Survey, and by 1285 it was known as Port Meadow, from its site near Port Street, the entrance to the city from the north. Freemen of the City were allowed pasturage for cattle and horses, and in 1970 there were still 210 men registering animals on the meadow. Shown left is how it appeared to 'The Silent Traveller in Oxford', Chiang Yee, in the 1940s. The watercolour is a view of Port Meadow by David Meakes. The commoners of Wolvercote were allowed to run poultry and geese here, but this often led to conflicts between the freemen and the commoners. *Jackson's Oxford Journal* records one dramatic incident of 1829: young Thomas Beesley and others were seen roughly shunting around the cattle, ducks and geese belonging to the men of Wolvercote. The Wolvercote men turned out for a fight, but the Beesley side chased the men back to Wolvercote and drove them into the Plough pub, where Thomas Beesley took hold of a bludgeon and fatally smashed one of the young men on the head.

The Thames from Folly Bridge to Sandford

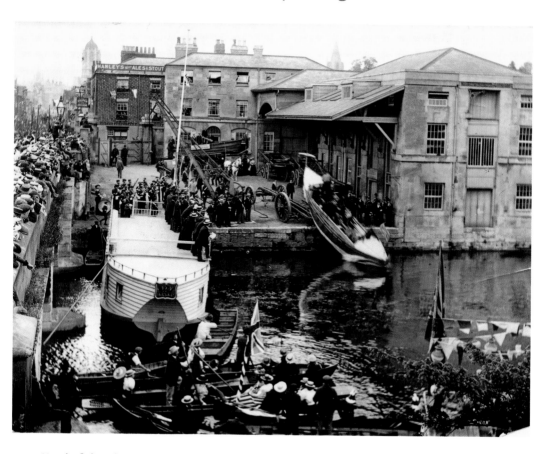

Head of the River

The Head of the River pub has occupied Salter's Brothers handsome boatyard building since the 1970s. J. & S. Salter took over the boatyard of Isaac King in 1858, just in time to take advantage of the burgeoning trade in pleasure cruising along the river. The firm built the wonderful college barges and racing boats. Here a lifeboat is being launched around 1900. Steamers ran between Oxford and Kingston-on-Thames, and Salter's Steamers still ply the Thames on day trips between Reading, Wallingford, Abingdon and Oxford.

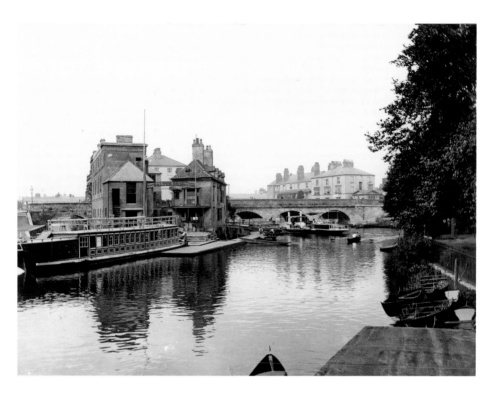

Salter's Steamers

A steamer service left this wharf twice daily for Kingston at its peak in the 1950s. Customers could stay overnight at hotels at different stops along the way. The enterprising brothers published *Salter's Guide to the Thames* and soon operated on Sundays and served alcohol, although this was against their sabbatarian principles.

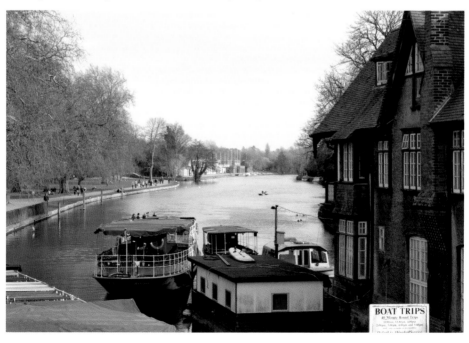

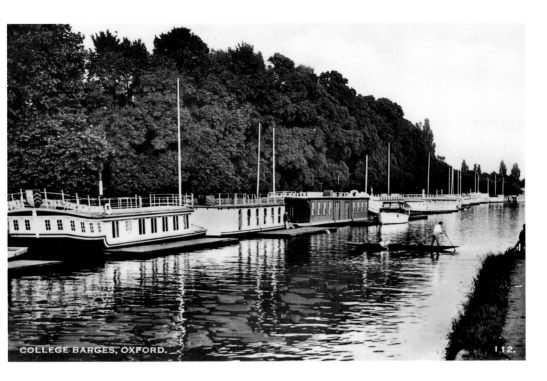

COLLEGE BARGES, OXFORD. 112.

Barges and Boathouses

College barges lined the river bank to allow their passengers to enjoy the racing events. Rowing competition between the colleges started in the late eighteenth century. In the next century, rules were established for the 'Summer Eights'. Some Colleges had their barges built. Others rented or bought them from the London livery companies, which had been commissioning barges for state occasions since the fifteenth century. Today it is the college boathouses that line the river. Christ Church was the first college to build a boathouse, in the late 1930s.

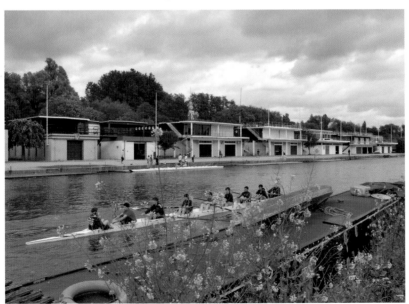

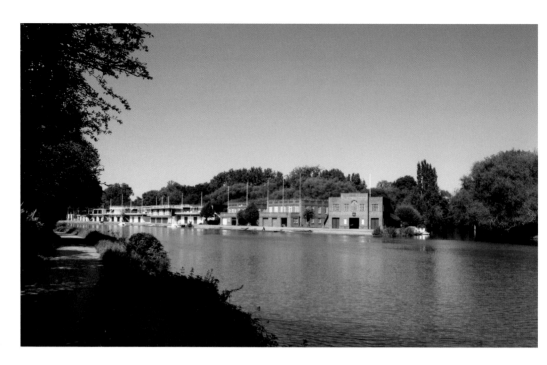

The Island

The boathouses, on an island created by a cut from the Cherwell to the Thames, had several advantages over the barges. Boats could be stored, more students could be accommodated moving around the island, security was better and social events could take place all year. The island provided both a launching pad and a viewing platform.

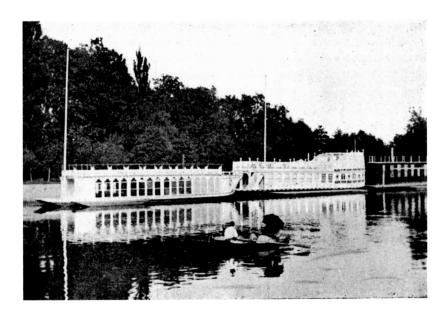

College Barges

By the 1970s the last of the college barges were out of use. One, which was left near Folly Bridge, was burnt before it could be restored. Another rests near Donnington Bridge, and St John's lies near Sandford. Magdalen College barge has been totally restored and is moored at The Swan, Streatley, while Jesus College barge is moored at Richmond Bridge. They can be rented for occasions.

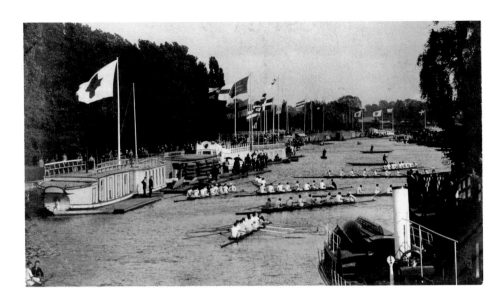

Summer Eights and Torpids

There are three major rowing races on the stretch of the river between Iffley and the Head of the River at Folly Bridge. The 'Summer Eights' began in 1815 as a spur of the moment race between Jesus College and Brasenose, with Brasenose becoming 'Head of the River'. Races start at this marker on the lock at Iffley and boats are eliminated by 'bumps' until one reaches the Head of the River. Torpids takes place in Hilary Term (February) and Commemoration takes place in June, but there are various other practice races throughout the year. A women's crew raced against Cambridge in 1927, and gradually the women's colleges gained full participation in the sport, especially as the colleges became mixed in the 1970s.

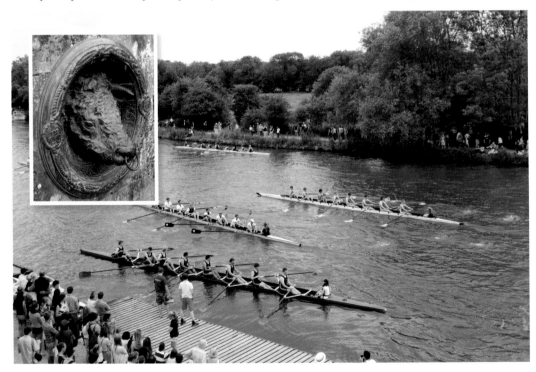

Isis Farmhouse Tavern

On the approach to Iffley you are greeted with the welcoming Isis Farmhouse Tavern. This pub has no road approach and is strictly for walkers, sailors and, of course, cyclists. Its outbuildings include former stables. The farm is adjacent to several lush meadows where ancient plant species can be found, such as the snake's head fritillary.

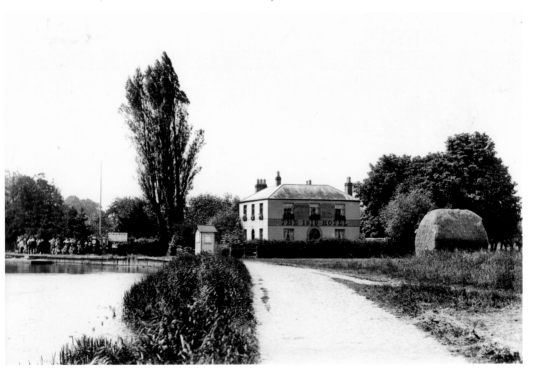

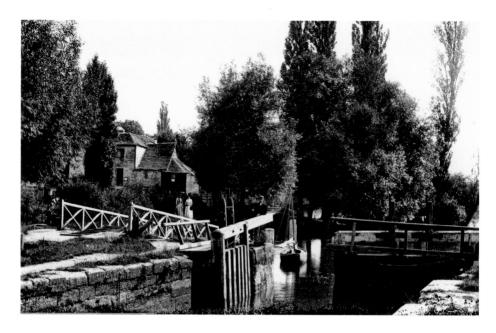

Iffley

Iffley village is a pleasant walk down the river – its outstanding twelfth-century Norman church is on the high ground overlooking the mill, the lock, and the little bridges, a perfect village scene of stone houses. The weir dates from 1302, when it was owned by Lincoln College. The pound lock, built by the Oxford-Burcot Commission in 1631, was the furthest upstream at the time, and the rollers still exist. This photograph of 1885 shows the lock with the mill in the background. Barges had to be hauled backwards over the rollers to sail upstream to join the Thames & Severn Canal, so improvements were made when the Thames Commissioners took over the locks on the river in 1802 and 1806. The current buildings date from 1927. The mill burned down in 1908, and the new lock house reflects its pitched roof and bulk satisfactorily.

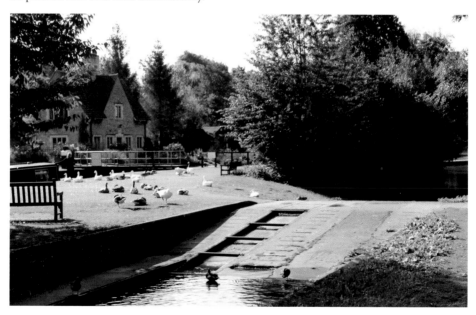

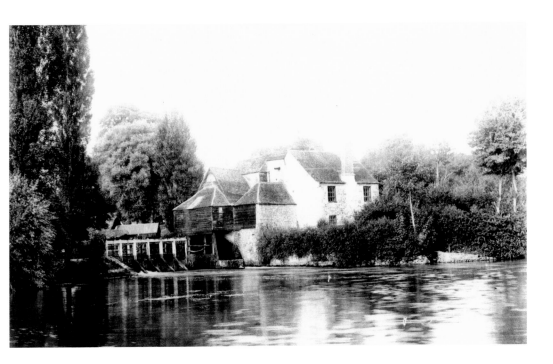

Iffley Mill

Iffley Mill dates from the thirteenth century. In the fifteenth century it was a 'double mill', with two waterwheels – one may have been used for fulling. By the seventeenth century, when the Thames was made navigable all the way to Oxford, there were many disputes between the miller and the bargemen over water levels, and some blame attached to the lock and weir at Sandford. The miller controlled the lock at Iffley, and the right to tolls. Henry Taunt photographed the mill before and after it burned down. It seems a shame now that this handsome timber-framed building could not be rescued.

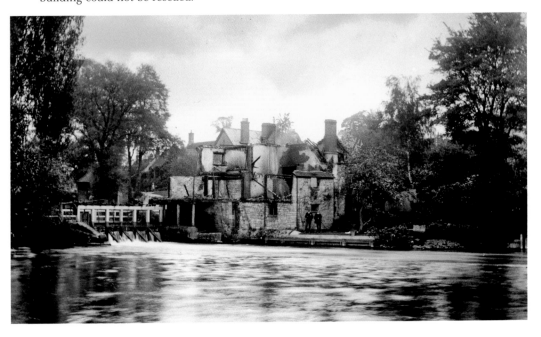

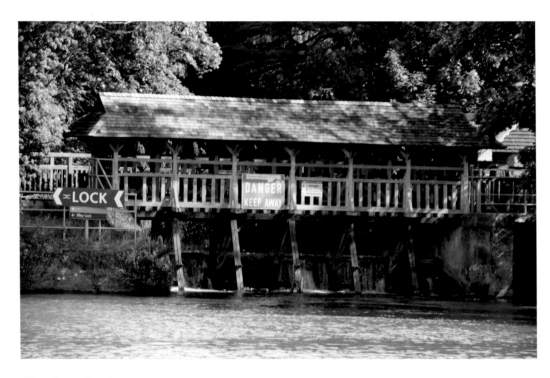

Iffley from the River
Leaving Iffley by boat, you catch a glimpse of the remains of the mill, its weir and mill race, over which you can walk to the centre of the village.

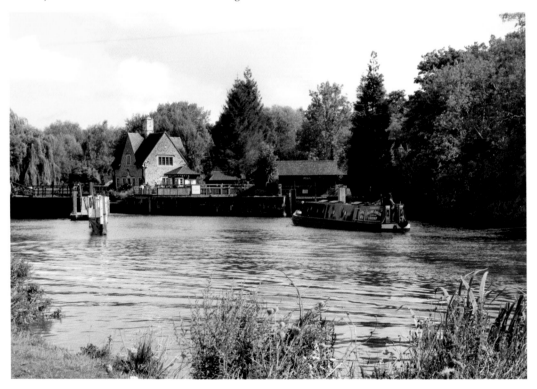

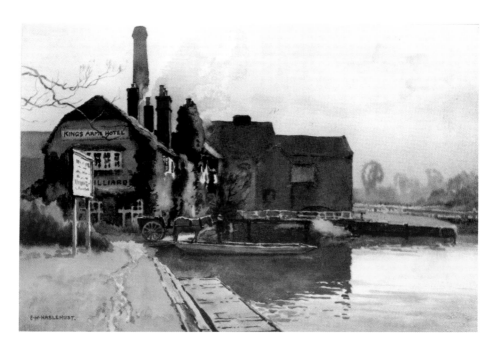

Sandford-on-Thames

The Kings Arms at Sandford-on-Thames (the Sandy Ford) was converted in the nineteenth century from a malthouse of the former mill. It stands by the lock; nearby there was a wharf and a ferry. There are generous riverside meadows, a reservoir pool, and a ferocious weir. There was a flash lock here in the Middle Ages, and until the improved lock was completed in 1632 barges had to use this inefficient system. At least one barge sank in the process.

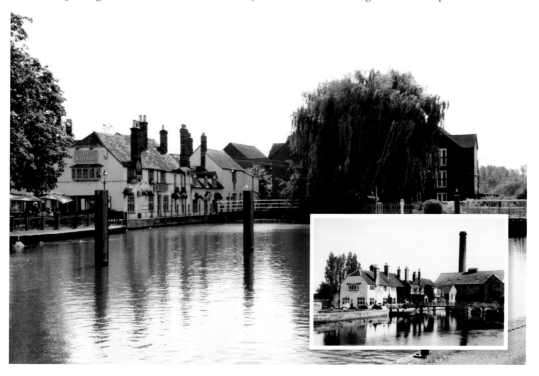

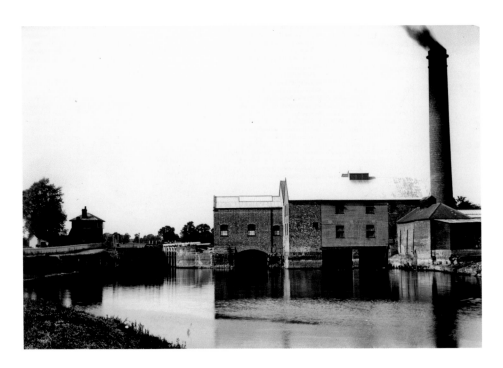

Sandford Mill

A mill was recorded here in the twelfth century, probably a corn mill on the site of the later paper mill, and the village once had two others. The mill may have been adapted to produce both corn and paper in the seventeenth century. A terrible accident occurred in 1806 when Thomas Durbridge was torn to pieces by the mill machinery, leaving a widow and four children, for whose relief a subscription was launched by the *Oxford Herald*. It was rebuilt as a paper mill by 1826. A second rebuilding took place in 1875, and in 1880 it was bought by Oxford University Press; it remained in operation until 1982. Water power had long since been replaced by steam, and in 1928 electricity was installed. The buildings were destroyed by fire in 1984, and the current waterfront buildings for housing reflect the bulk of the mill as it was.

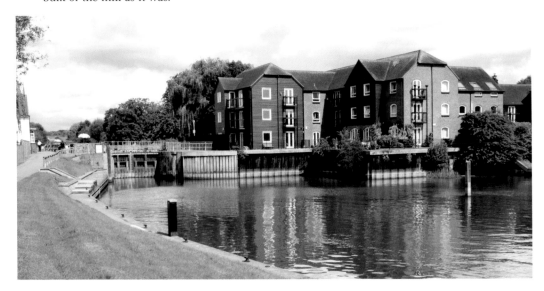

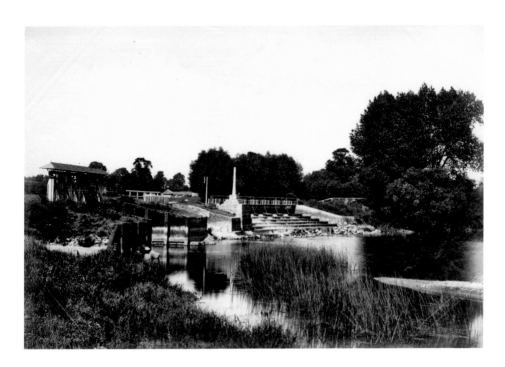

Accidents on the River

Sandford was no stranger to disaster. Students often rowed down the river to escape the supervision of the 'Bulldogs', as the University Police were known, and to exploit welcoming local pubs. One such excursion to Iffley was the start of the racing tradition. But in 1735 a group of students left Oxford in the early hours and, as a dare, attempted to 'shoot the lock' at Sandford to avoid paying the miller to pass, with fatal results. The weir just above the lock controls the flow to the mill, the lock and the river, and has an overflow to the Old Lock Pool. The obelisk on top of it (inaccessible to walkers) is a memorial to a number of students, from Christ Church in particular, who drowned swimming here between 1843 and 1921. Three students drowned here in 1921, one of whom was Michael Llewelyn Davies, the adopted son of J. M. Barrie. He was the inspiration for the character Peter Pan.

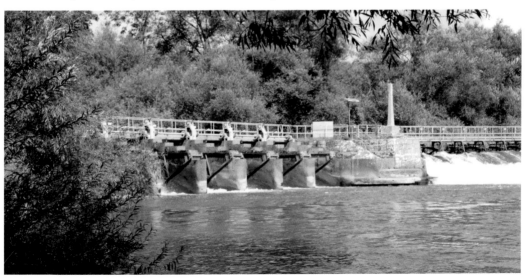

The Pleasures of the Cherwell

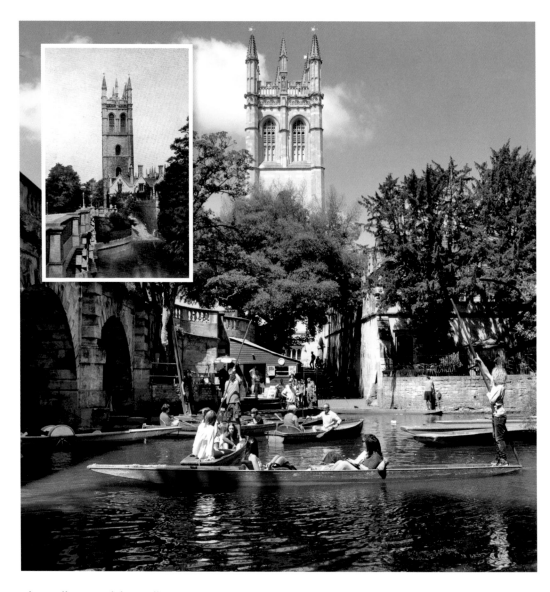

Cherwell at Magdalen College

The Cherwell rises up in Northamptonshire among the ironstone hills. On its journey to the Thames at Oxford it passes through soft, idyllic countryside – part of the way it is incorporated into the Oxford Canal. It meanders through villages and reaches the city at Summertown and Marston. Its most famous site is at Magdalen College, where the bridge makes the entrance to Oxford from the east, a view hardly changed through the centuries.

The Idyllic Cherwell

The Cherwell now is devoted to pleasure. Its back door to Oxford looks out onto colleges, riverside pubs, the University Parks, surrounds Christ Church Meadow and passes behind the boathouses. In the past it was crossed by several fords and ferries, and drove many mills. Its meadows provide a 'green lung' for the city. Too low-lying for building, it is a refuge for plants and birds, and a gentle introduction to rowing, punting, and swimming.

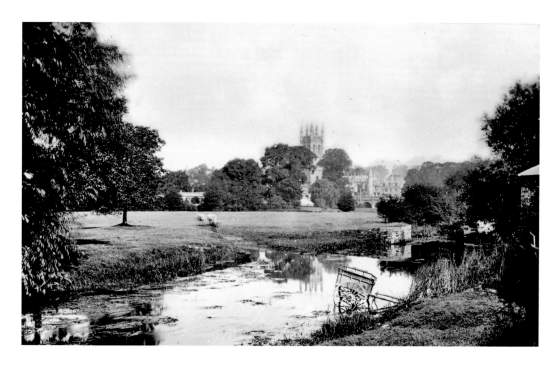

Magdalen Tower and Botanic Gardens

A fine view of Magdalen Tower from the Cherwell at Milham Ford in 1870. The river bounds Christ Church Meadow and the Botanic Garden. The Garden, founded as a source of medicinal plants in 1621, is the oldest in the country, with an imposing gateway dating from 1632/33. This scene hardly changed until St Hilda's College was founded in 1893, initially as a hall for women.

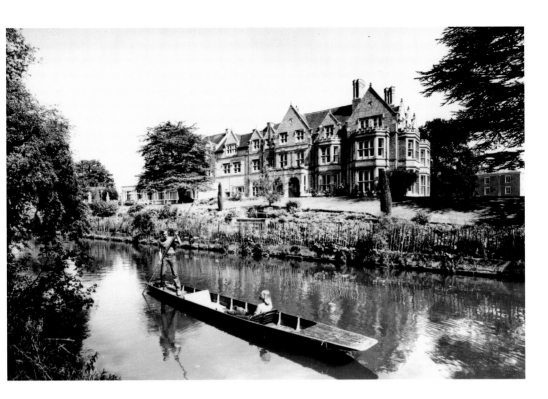

St Hilda's

St Hilda's has built several new buildings along the river to add to this imposing nineteenth-century block, notably the Jaqueline de Pré Music Building in 1995, an important addition to the few purpose-built concert venues in the city. The bank had to be built up for construction, and the Milham Ford Building sometimes floods. The Cherwell here makes pleasant punting.

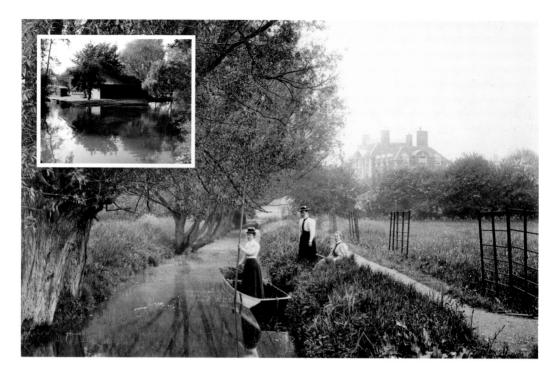

Women in the University

No sooner were women admitted to the University than they began to take part in sports along with the men, including punting, rowing and swimming. Here they punt along Lady Margaret Hall's reach of the Cherwell in 1895, with the college's Talbot Hall building in the background, only just visible now through the trees. LMH, as it is known, was the first of the women's colleges. It was founded in 1878, with extensive grounds and gardens along the river. The college had an early boathouse too.

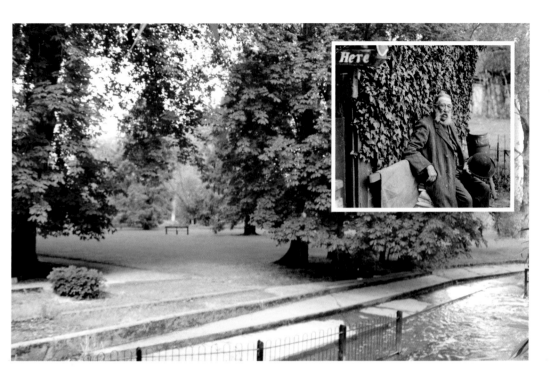

Parson's Pleasure and Dame's Delight

Parson's Pleasure, the University's private bathing place, is no more, but here on this green sward were changing rooms and a screen of trees to enable dons to bathe in the nude all year round. Charles Cox, the proprietor, surveys his charge, aged eighty-eight (*inset*). He died in 1917. It was all removed in 1991 – ''elf 'n safety'? Dame's Delight for the women was on the opposite shore. Now only ducks can enjoy the pleasure of the Cherwell here, the weir makes it too dangerous.

47

Mesopotamia

The bathing place was near the weir. Rollers nearby enable punts to be carried past the weir onto the braided channels below. A footpath runs along Mesopotamia, the land between the rivers.

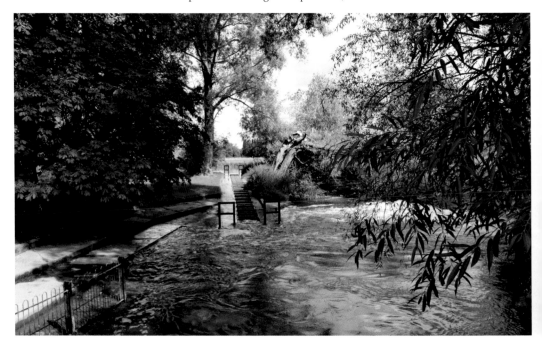

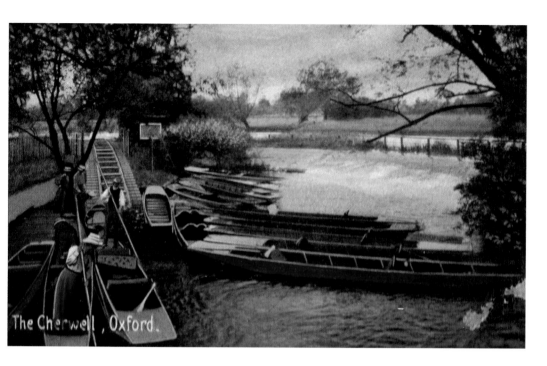

The Cherwell, Oxford.

Summertime
This postcard, sent in August 1908, recalls summer vacations and leisure time on the Cherwell. It can be challenging to lug a craft along the rollers!

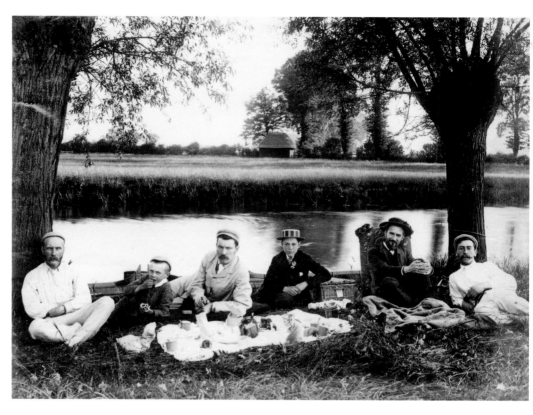

Relaxing by the River
Déjeuner sur l'herbe and other pleasures along the Cherwell!

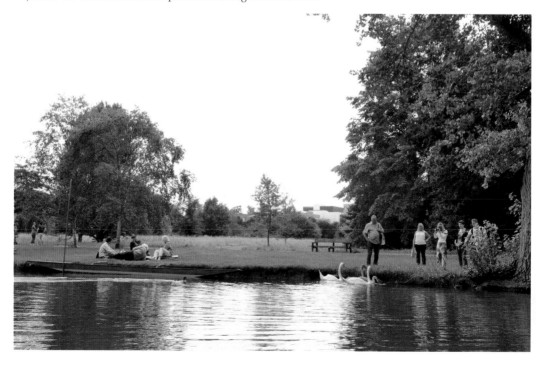

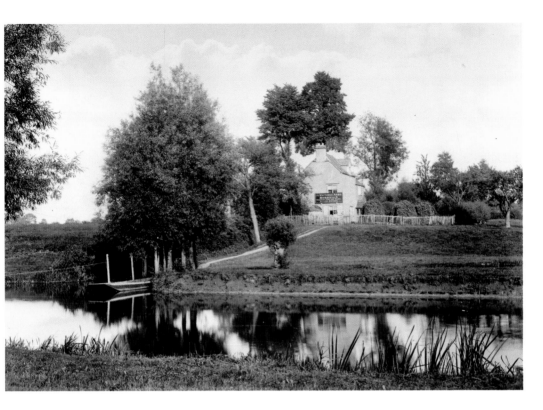

Old Marston

Old Marston lies on a bank of the Cherwell, separated from the city by an expanse of meadow. Its character changed forever when the northern bypass was built in 1932, and then the Marston Ferry Link Road divided the meadows in 1971. These roads cross the Cherwell as if it wasn't there. The villages on the ragstone ridge above Oxford used to have a ferry to let their inhabitants cross.

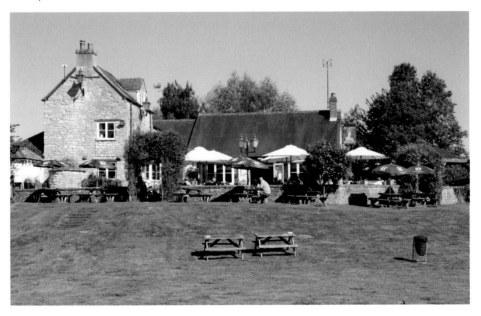

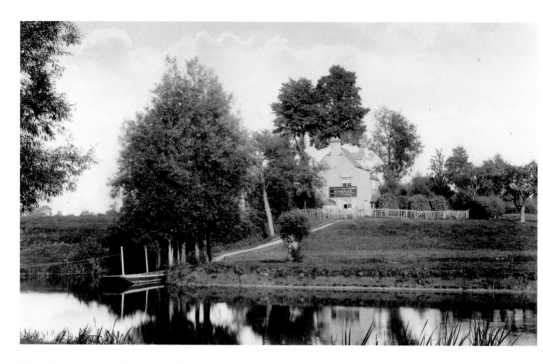

Victoria Arms and *Frenchman's Ferry*

The ferry dates from the thirteenth century, and the pub at its crossing was known as the Ferry Inn until the late nineteenth century – probably changing its name to the Victoria Arms for the Jubilee of 1897. From 1871 both the pub and the ferry were run by a Frenchman, Victor Biovois, and the ferry was known as *Frenchman's Ferry*. Some of his descendants still live in Marston.

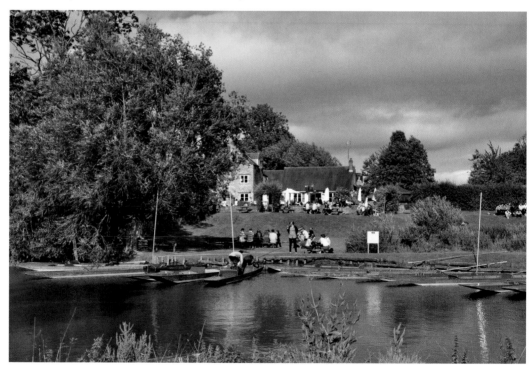

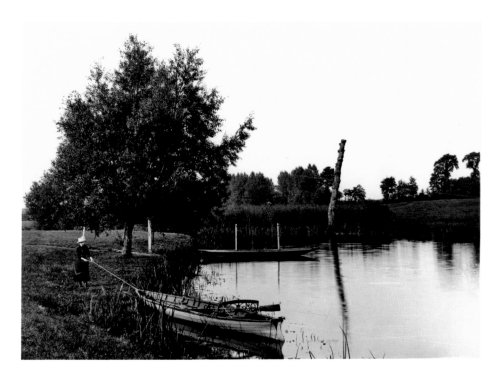

Meadows at Marston

The Oxford Preservation Trust bought the meadows at Marston to protect the city's green borders in 1927. In the 1950s it bought the Victoria Arms too, to ensure the rural character of the area was preserved. Some remnants of the ferry landing can just be seen.

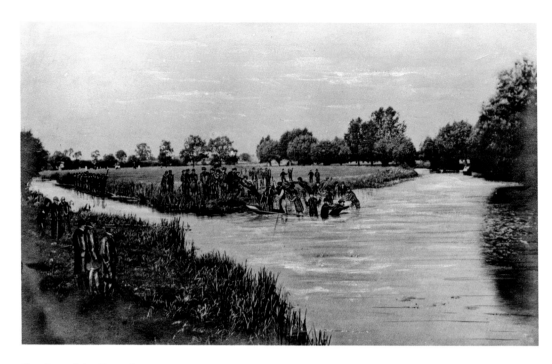

Beating of the Bounds

The Beating of the Bounds was a parish tradition going back to the Middle Ages. Marston, is one of the sites where 'Beating the Bounds' passes, sometimes with hilarious results, such as this sinking of the mayoral punt in 1892. This boundary stone stands next to King's Mill on the edge of the Parks.

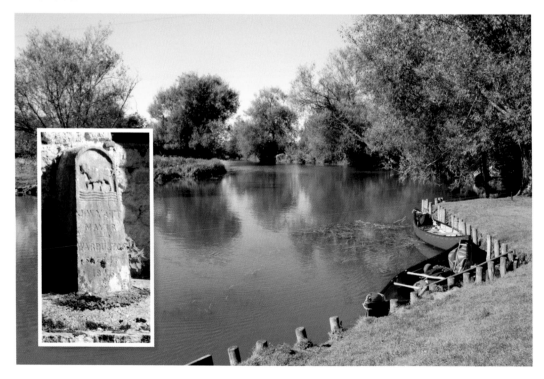

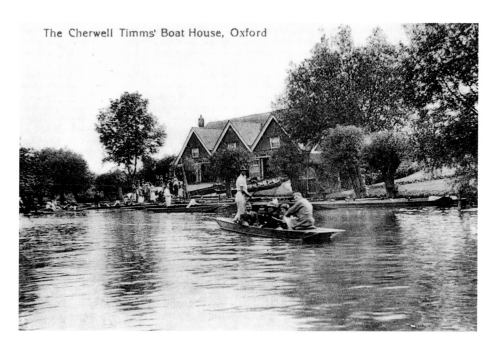

The Cherwell Timms' Boat House, Oxford

Timms' Boathouse

Not far downstream, the Cherwell Boathouse is a popular restaurant. It preserves its boathouse origins by continuing to hire out punts and small rowing boats. St John's College leased a landing stage to the University Boat Club's waterman Tom Timms in 1901, and his boathouse was of course known as Timms' for the next forty years. A café has been added next to the main boathouse, but otherwise it has hardly changed.

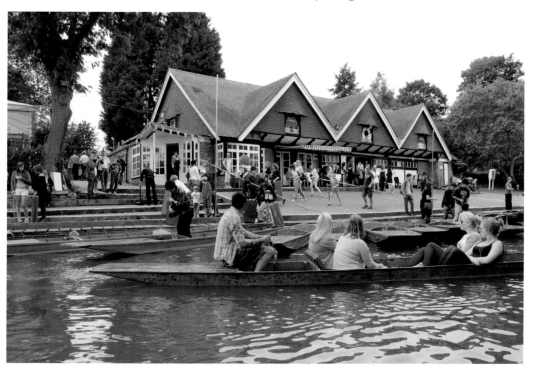

Skating on the Cherwell

The Cherwell enters the Thames at the edge of Christ Church Meadow, crossed by this Chinese-style bridge. When a cut was made to form the island for the boathouses, and to relieve the flooding on the meadow, no bridge was made. The meadow saw skating on the Cherwell here in 1895, one of the worst winters ever.

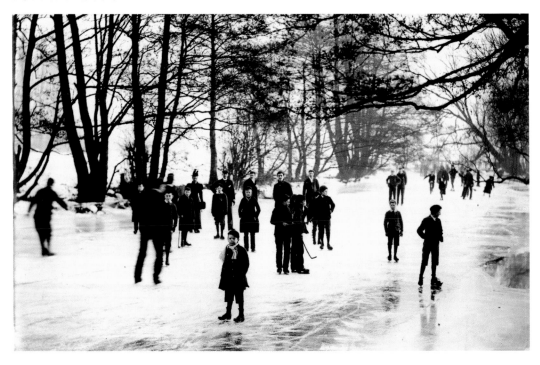

Mills and Streams

Mill Streams

The wide river valleys are braided with smaller streams. In Saxon times, every abbey had its selection of mills, for corn, grist, paper and fulling, all of which were powered by these streams. In addition water was required for washing, softening flax fibres, tanning leather, brewing and a host of other trades that made up a self-sufficient community. We have looked at the large mills on the Thames – Oseney, Iffley, Wolvercote and Sandford. Now we will explore some of the smaller relics of the waterways of Oxford.

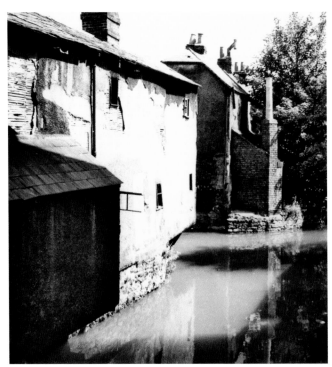

Wareham Stream

Behind the majestic Castle Mill, with its wide mill stream, ran a back stream, now known as the Wareham Stream, which made an island out of Fisher Row. Today it is hard to imagine how the cottages fitted into the narrow bank. One way of solving the problem of space was to build over the stream. The flow to the Wareham Stream was regulated by the lock halfway along the bank of Lower Fisher Row. It lay beyond the raised floor of the back of this cottage over the stream, just below the tree in pink flower in the modern picture.

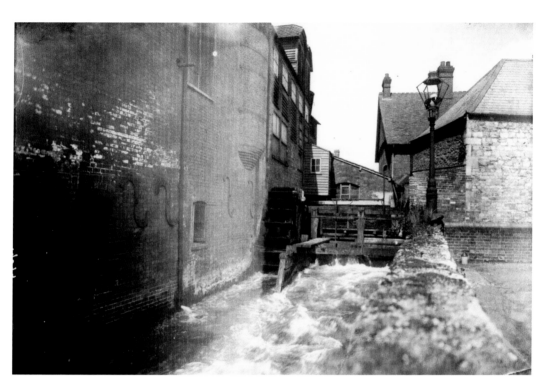

Lion Brewery

The Lion Brewery used this waterwheel on the Wareham Stream until 1880. Not many people know that the wheel is still *in situ* behind the brewery even though the buildings were converted into apartments early in the twenty-first century.

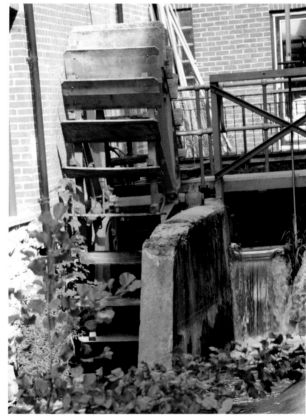

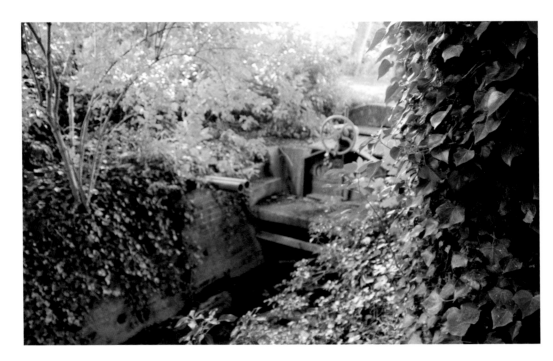

Trill Mill

The Trill Mill Stream is another secret of the Thames. Trill Mill was first recorded in the twelfth century. It was situated on a stream that ran from the Castle Mill Stream around the walls to near St Frideswide's Priory (which owned the mill at one time) and then to the river from the meadow. Its millers were involved in frequent disputes with millers of Blackfriars nearby. The mill stream is 1.2 km long. Most of it now runs in a culvert, but it can just be traced from this sluice off of the Castle Mill Stream to Christ Church Meadow where it joins the Thames.

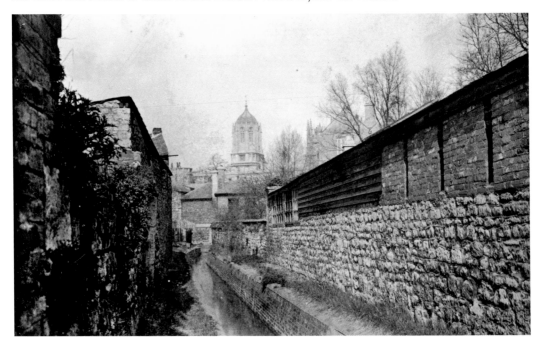

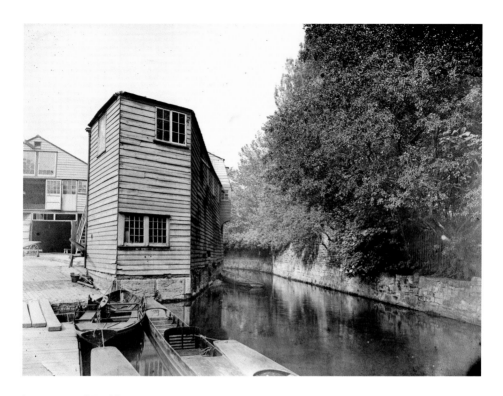

Lawrence of Arabia

The Trill Mill fades from history by the seventeenth century but in the tradition of daring exploits by college undergraduates, T. E. Lawrence (of Arabia) claimed to have taken a canoe through it from the Castle Mill Stream to Christ Church in 1908. In the 1930s the stream was dredged and a Victorian punt with three skeletons aboard was found – did they get stuck or die of fumes? There are many claims of successful attempts to navigate it.

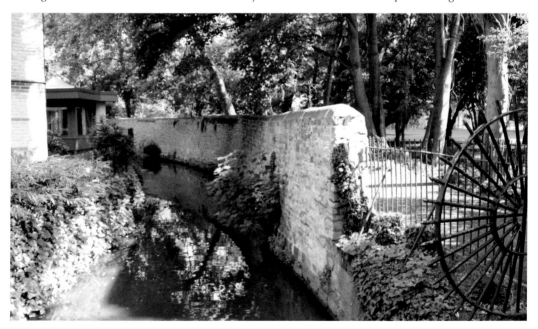

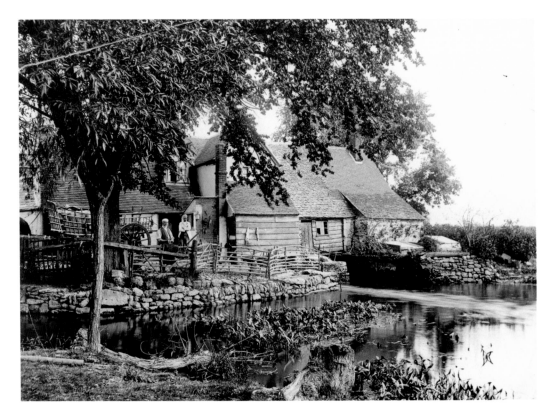

Hinksey.

Hinksey had many mills too, and a ferry to cross the stream (in fact the area is still known as Ferry Hinksey). North Hinksey Mill, photographed here in 1885, is typical weatherboard construction. Note the farm wagon, probably a Berkshire type, and the hurdles, which present a rural picture on the outskirts of Oxford. This mill burned down, but I think I found the traces near Red Bridge.

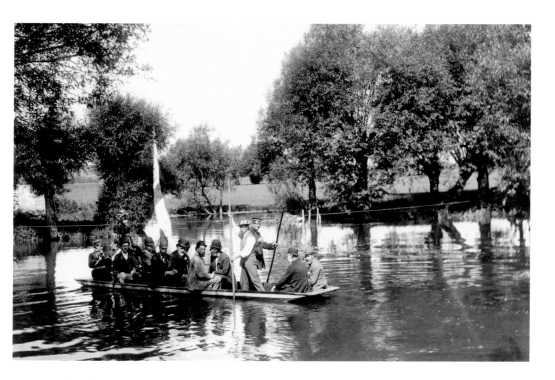

Beating the Bounds at Hinksey

Every parish within and outside the city had its Beating of the Bounds ceremony, one purpose of which was to let parishioners know which parish they were in, and therefore where they were entitled to be buried. it was also intended to deter encroachments from neighbouring parishes. As streams frequently formed the boundary of a parish, they featured regularly in the collective photographs. The mayoral punt is shown here on the Hinksey Stream in 1892.

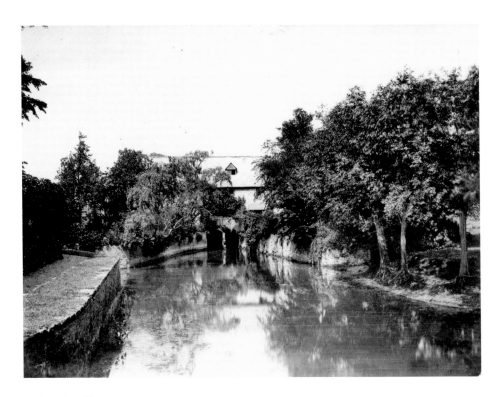

Holywell Mill

In Magdalen's garden grounds, Holywell Mill was a working mill in 1876 but is now a private house. It has previously been in the hands of Oseney Abbey and Merton College, which exchanged it with Magdalen for other property in 1877. Visitors enjoy the surprise of its quaint appearance in Magdalen's grand grounds next to its deer park.

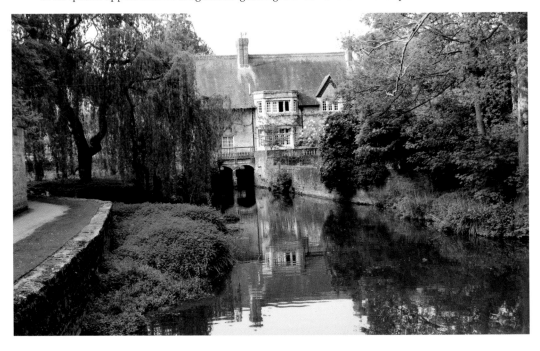

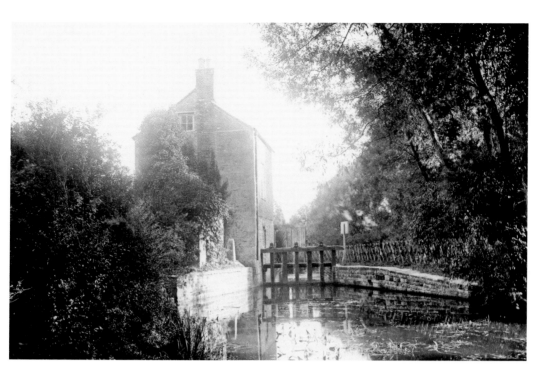

King's Mill

King's Mill on the Cherwell was one of the medieval mills of Headington parish and it was working until 1832. It is on the boundary of the University Parks and is now let privately. You can see the old boundary stone against the wall of the outbuilding in both photographs. Some parishes still carry out the Beating of the Bounds around the colleges, shops and streets that form their ancient boundaries.

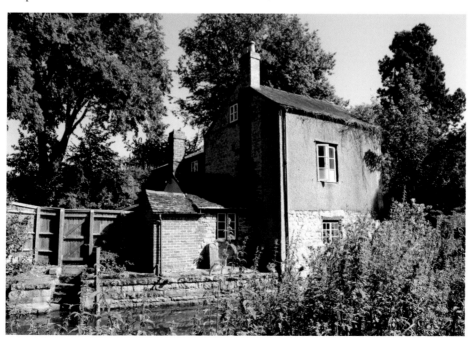

The Oxford Canal

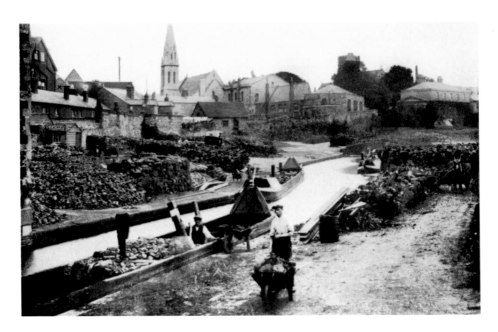

The Oxford Canal
The wharf at Hythe Bridge in the centre of Oxford was the terminus of the Oxford Canal, known colloquially as 'the Oxford', completed in 1790. The first 10 miles of the canal from Coventry had opened in 1771, but it took the remaining years to raise money and get approvals for the entire length. The impetus to build it had come from the owners of the coal mines in the north, who recognised that there was a market for coal at cheap prices in the southern Midlands. The wharf was infilled in 1954 and is now the car park on Worcester Street.

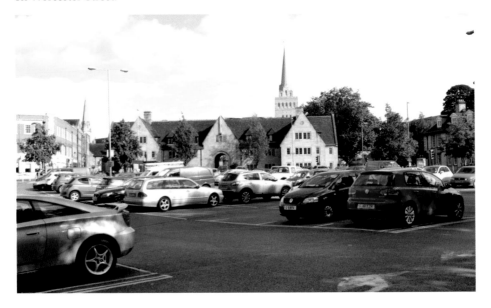

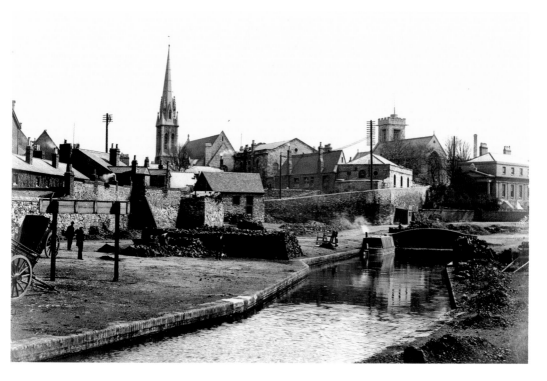

Coal

By 1793, 55,893 tons of coal came down the Oxford to wharves at Cropredy, Banbury, Aynho, Heyford, Enslow and Oxford. We shall visit these in order from Oxford northwards. In 1794 Richard Tawney was appointed engineer for the Company and had this classical Canal House with porticos built as offices overlooking the wharf in 1827. Seen on the far right of the 1901 photograph, it is now the Master's Lodgings of St Peter's College.

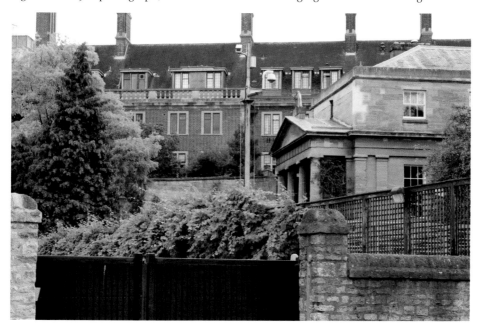

Canal Company Warehouses and Nuffield College

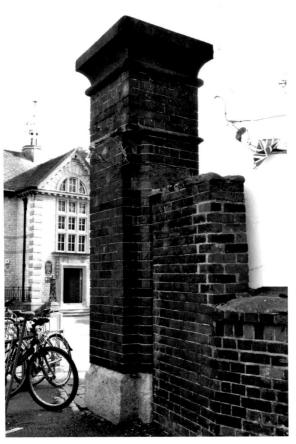

Large Canal Company warehouses sprung up soon after the terminus was reached. They were built between 1791 and 1795 using the cheap labour of felons from the nearby Castle Prison, under the agency of Daniel Harris (governor of Oxford Castle Gaol), who had also supervised their work on Godstow Lock and Oseney Lock. William Morris, later Lord Nuffield, bought the underused Canal Company buildings and wharves in 1936, but the construction of his Nuffield College buildings did not begin until after the Second World War. Ironically his fortune came from the motor car business, one of the destroyers of the commercial canal traffic. A small pond in the quadrangle of Nuffield recalls the wharf. This blue brick pillar is all that is left of the wharf entrance gates.

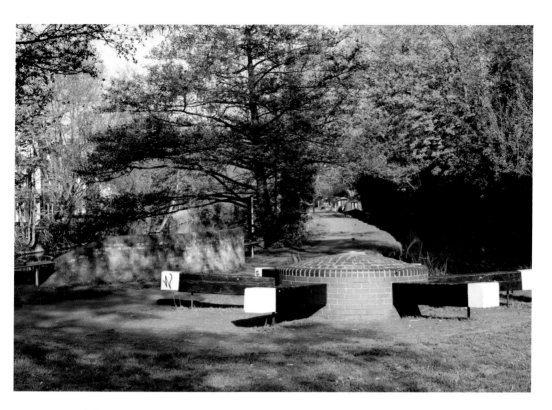

Upper Fisher Row
This capstan has been placed as a reminder of the active canal at the current stunted terminus at Hythe Bridge Street, next to the 'armchair weir'. From the wharf the canal ran parallel with the Castle Mill Stream as far as the Isis Lock. Here the Upper Fisher Row overlooks them both.

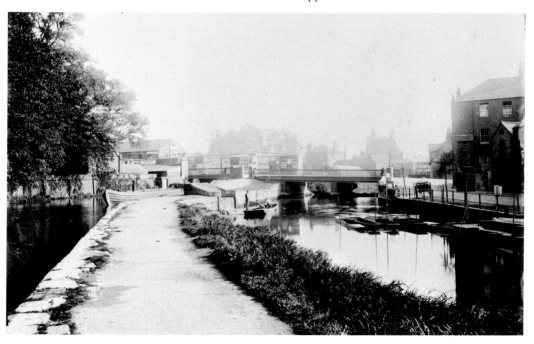

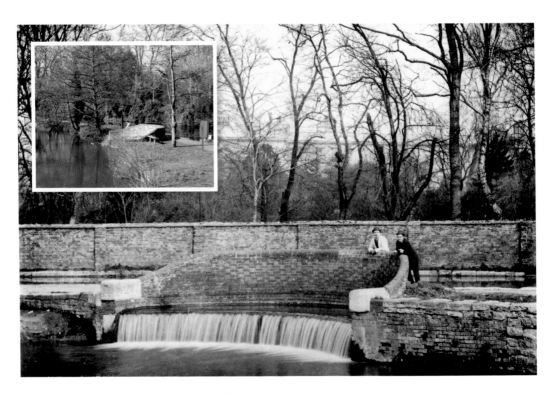

The 'Armchair Weir' and Worcester College

Above, the 'armchair weir' is shown in its prime and today. Looking northwards past the 'armchair weir', the stream from Worcester College enters the river. The growth of vegetation on the towpath now that horses do not pull the barges or narrowboats is noticeable. This narrowboat, named *Fanny*, is moored near Worcester College's frontage. Henry Taunt photographed the canal extensively between 1880 and 1905.

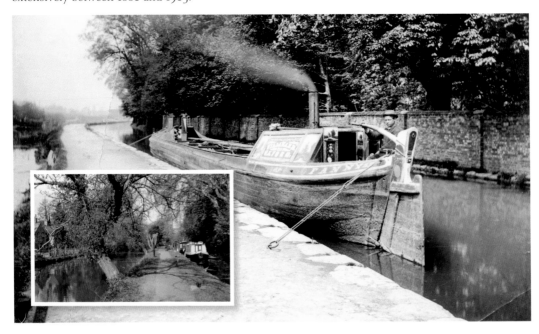

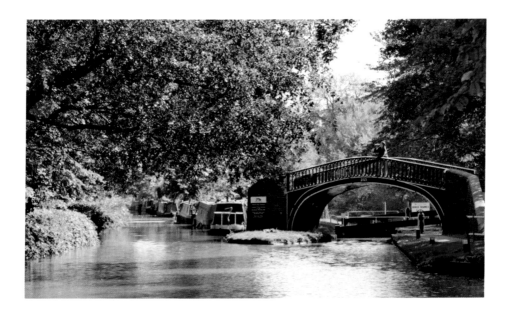

Isis Lock and Bridge

Isis Lock's attractive bridge dates from 1844, when the lock, which opened a channel to the Thames, was rebuilt. It was narrowed, in fact, so that only narrowboats could pass through and not river barges. The river trade to the wharves was already lessening owing to the Grand Junction and Thames & Severn Canals bypassing the centre of Oxford on the way to London. The railway was soon to take its share of the trade. Locals know it by 'Louse Lock'. This view dating from the period 1915–25 looks back towards the wharf from the painted cast-iron bridge. The canal is on the left, the Castle Mill Stream and the entry to the Isis are on the right.

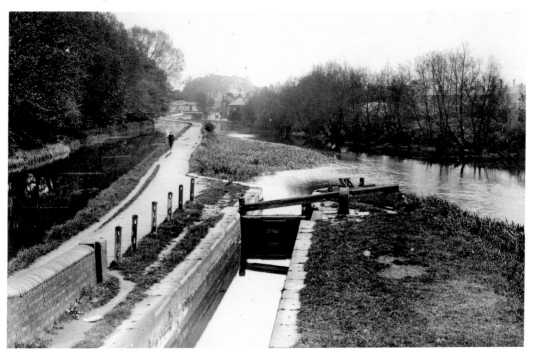

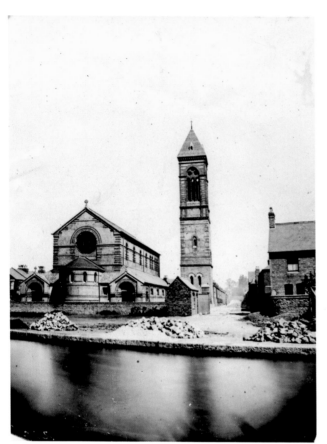

St Barnabas

St Barnabas church in Jericho was a latecomer to the canalside scene. It was built in 1869–72 to the stern instructions of Thomas Coombe, superintendent of the nearby Clarendon Press, to be simple and solemn. Thomas Hardy set a crucial scene in *Jude the Obscure* here, and its severe presence still dominates tiny Jericho. The lively Castle Mill Boatyard, at Ward's Wharf in front of the church, closed in 2005 and, after turbulent local protests, has been sealed off until some agreement can be reached as to the development of the site for housing and community use. It has been the setting for an *Inspector Morse* mystery and for Philip Pullman's 'His Dark Materials' trilogy. Its shambolic disarray has long held a certain fascination for local people.

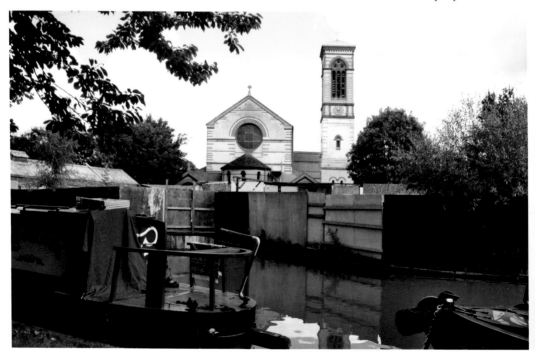

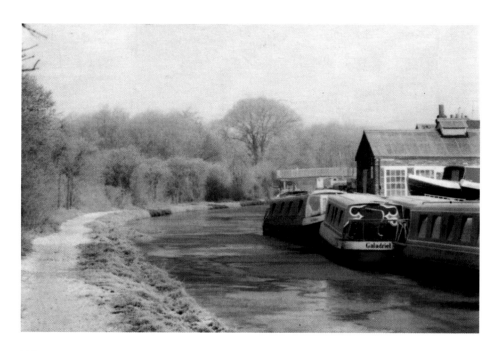

Wharves

This postcard of 1988 shows a serene scene. Many of the buildings from the boatyard and wharf remain on the boatyard and College Cruisers site, but for how long? At one time wharves for stone, wood, coal and slate lined the entire length from here to the terminus.

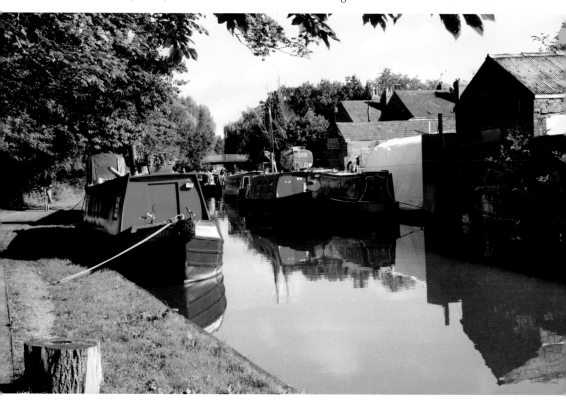

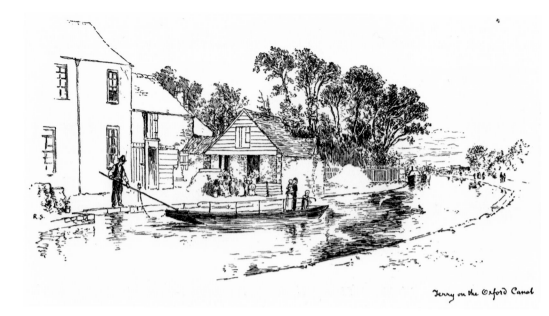

Ferry on the Oxford Canal

Jericho and *Herbert's Ferry*

The Jericho ferry, another enterprise on this short stretch of canal, operated from 1868. It was known as *Herbert's Ferry*, after the family who operated it and lived in Ferry House next to it until 1927. It cost half a penny to go across in the chain-operated punt. This illustration is from A. J. Church's *Sunny Days on the Thames* of 1886. The footbridge that replaced the Jericho ferry was a long time in coming – it was constructed in 1972. The length of the canal between Walton Well Road and Worcester College had been meadow land, known as Great and Little Bear Meadows until the marshy land was finally developed into the little suburb that is now Jericho after 1874. This development was due largely to the location of the University's Clarendon Press on Walton Street, and the consequent need for housing for its workers. But the area had a bad reputation as a rough neighbourhood of boatmen and wharf workers, both liking their beer.

Juxon Street Wharf

A small park is all that is left of Juxon Street Wharf, which used to be thronged with barges unloading coal. The footbridge now overlooks the site where Rose Skinner (bottom) and Jean Humphries (top) worked up to 1956.

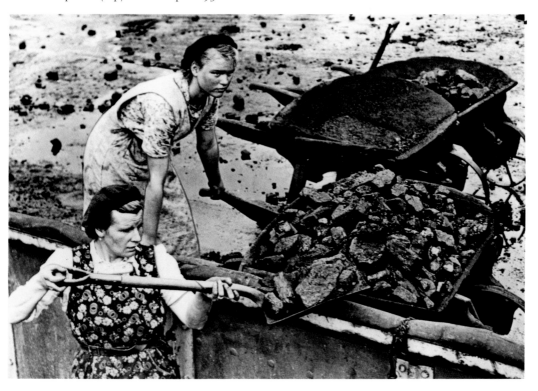

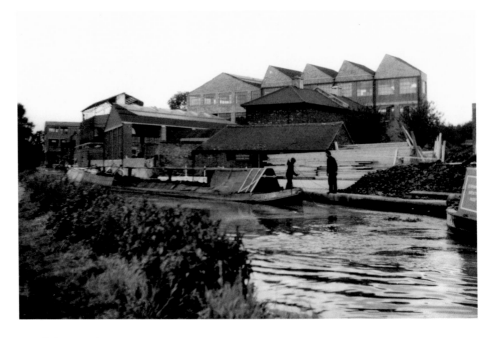

Lucy's Ironworks

The Eagle Ironworks, later Lucy's, was moved from its Summertown foundry to the canalside in 1825. William Lucy's ownership dates from 1861, and under his management production expanded from ornamental ironwork and street furniture to electrical engineering. Library racking was supplied all over Oxford, including the world's first rolling stacks to the Radcliffe Camera underground storage levels. However, Lucy's location in an increasingly residential area next to Jericho and North Oxford limited the scope for expansion, and the works closed in 2002. Operations moved to Dubai. Apartments reflecting the red-brick industrial factory design now occupy the site.

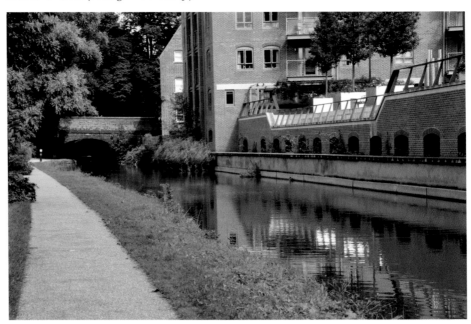

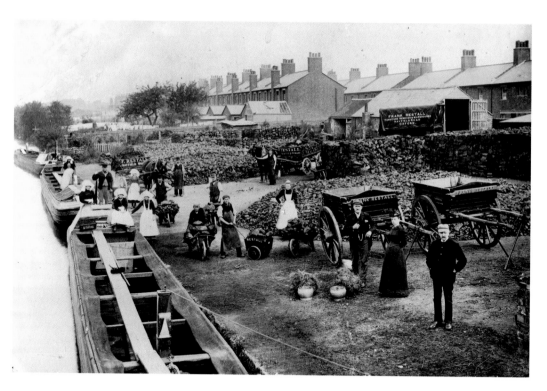

Hayfield Wharf

Hayfield Wharf seen here in 1890 was thronged with barges bringing coal, stone and slate down the canal. On the southern edge is the Anchor pub, formerly Heyfield's Hut after its long-serving landlord William Heyfield. Another pub, the Navigation Arms, was also built on the wharf, and survives only in a street name as the area has been redeveloped. The tidy row of houses behind the wharf date from the 1880s, and now have desirable canal frontages.

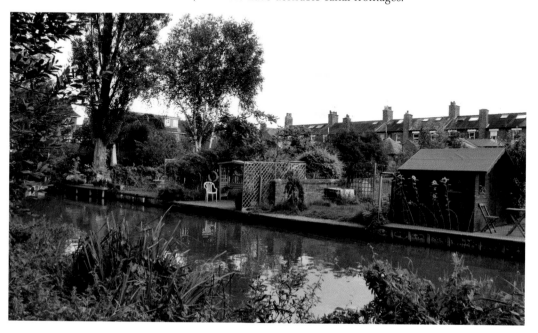

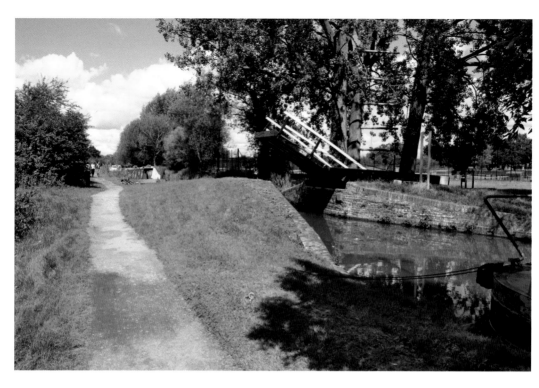

St Edwards School Lift-bridge

St Edwards' bridge is typical of the lift-bridges along the Oxford Canal and dates from 1831. It is known as St Edward's after the nearby school, but the school's foundation on Woodstock Road dates from 1873. It seems to have been for use by farmers bringing their livestock across the canal. This rural view from 1924 has hardly changed.

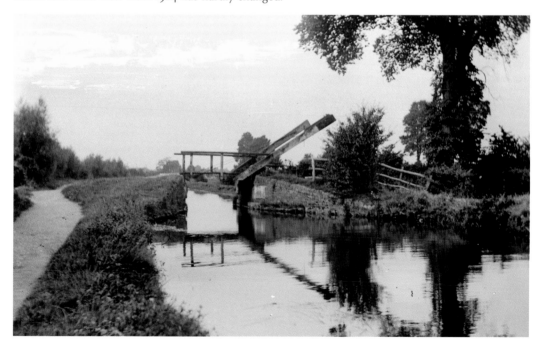

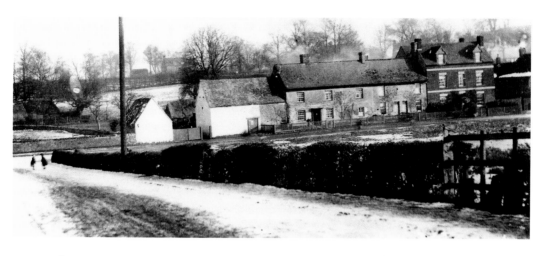

Wolvercote

Wolvercote Lock is crossed by a road bridge that spans both the canal and the railway. It is a rebuild of the 1840s to replace the original bridge that crossed over the canal alone. Here the canal and the railway divide the little village in two: Upper Wolvercote by the canal and Lower Wolvercote by the river. Upper Wolvercote has its own green, and The Plough has served the village and canal people since at least 1812.

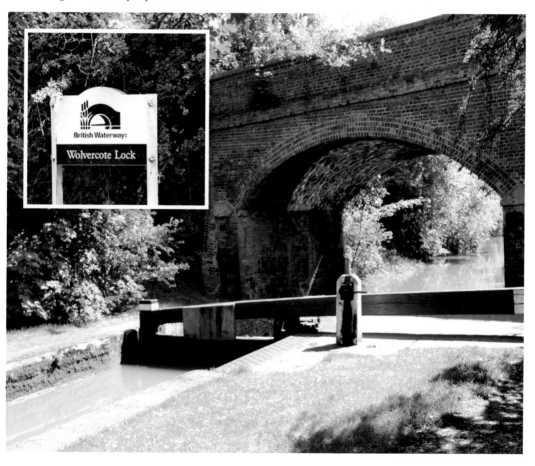

The Plough
The Plough was the scene of the violent clash between some boatmen and fishermen of Fisher Row and the men of Wolvercote, who traditionally kept geese and poultry on Port Meadow.

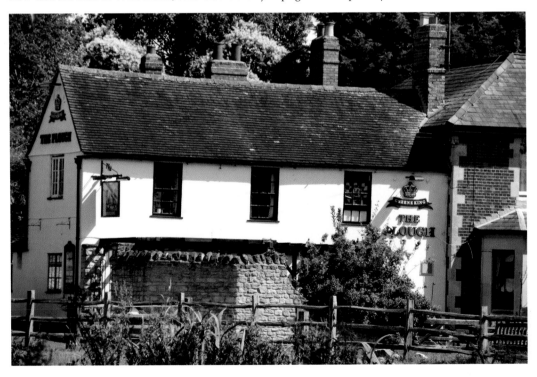

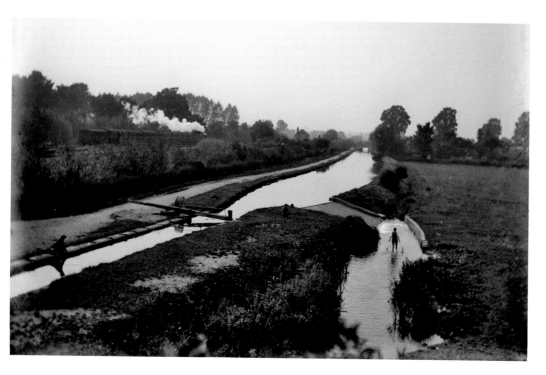

Goose Green

On the northern side of the road bridge Wolvercote Green is known as Goose Green, and a reservoir remains in place here, used as a boat turn for boats returning from Wolvercote Wharf northwards. It is seen here in 1922.

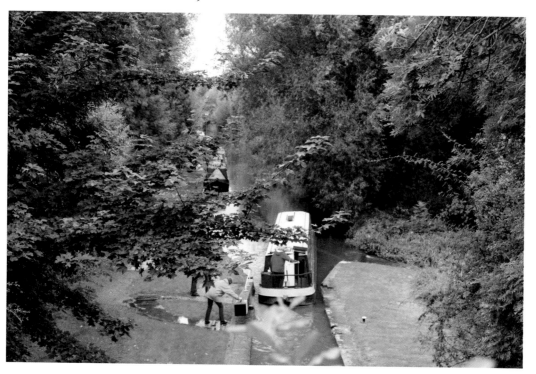

Duke's Cut

Here at the Duke's Cut, narrowboats can join the Thames, a few hundred yards to the west. The cut was made when the canal was built at the expense of the 4th Duke of Marlborough to enable deliveries of raw materials, and later coal, to Wolvercote Paper Mill, which he owned and leased to the printer William Jackson. There is no towpath and walkers are disappointed.

We will travel with 'the Oxford' from the Duke's Cut northwards to the rural communities where the wharves traded in the local produce, and most importantly, imported coal at affordable prices from the Midlands for their cottage fires. The advantage of bringing cheap coal to the rural poor was one of the arguments used by the promoters to get agreement to build the canal. Around the western edge of Kidlington, then a small village of stone cottages clustered around the church and mill, the canalside sports new houses, now that it is desirable to have a canal frontage. The main wharf was at Langford Lane, and was soon joined by the railway station of the Oxford–Rugby line in 1852.

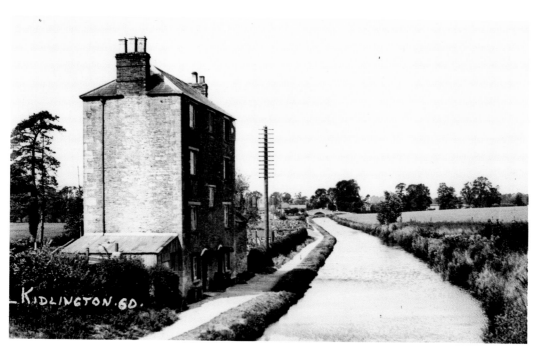

KIDLINGTON. 6D.

Mount Pleasant and the Wise Alderman

The Oxford makes a loop around the centre of Kidlington, and here on the Oxford–Banbury road it is crossed by a bridge and runs for a long stretch almost parallel with the Cherwell. The bridge was widened and the road straightened in 1936 and this four-storey house, Mount Pleasant, was demolished. It was opposite the Wise Alderman Pub, named after Alderman Frank Wise, OBE, who held many parish and county offices. It is now renamed The Highwayman and its garden overlooks the canal and some of the former wharf buildings.

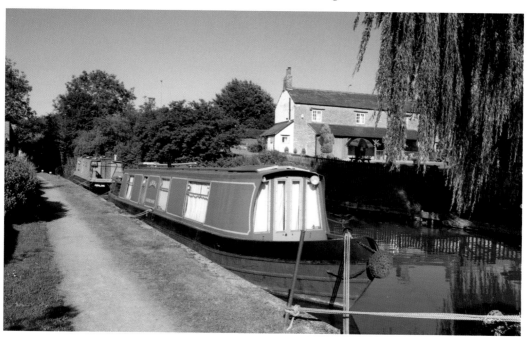

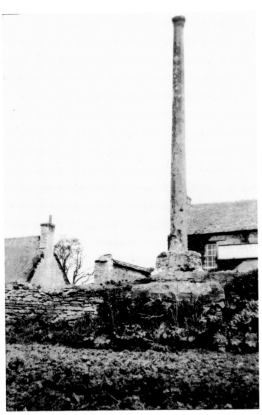

Icebreaker at Thrupp

Thrupp has a generous basin and a lock, and now serves a thriving pleasure cruising crowd. Its two pubs and row of cottages (formerly called Salt Row) cluster around its ruined fifteenth-century cross, of which only the very tall shaft remains (*inset*). The Canal Company kept a small icebreaker boat here, along with others at Lower Heyford. They were pulled by ten horses and also required a number of men to rock the boat against the ice to break it.

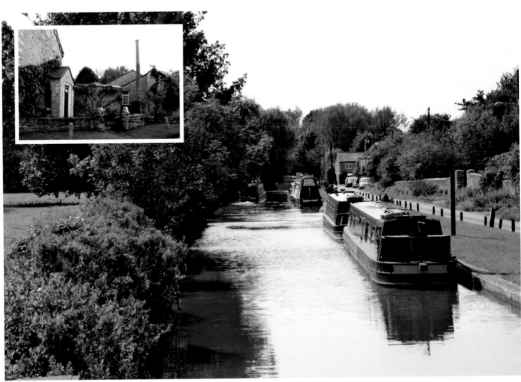

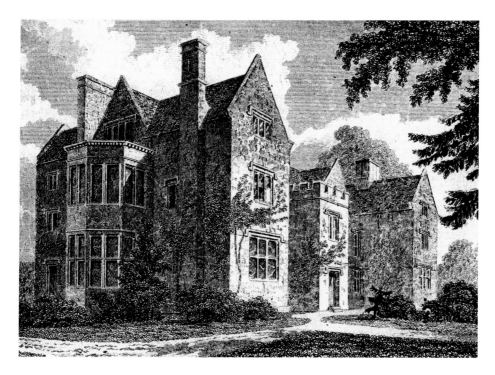

Hampton Gay Manor

Through the fields opposite Thrupp lie the ruins of the large sixteenth-century Hampton Gay Manor, which burned down in 1887, causing the population of this already small parish to decline to just thirty souls. The manorial corn mill had been converted to produce paper since 1681, but it was also destroyed by a sequence of fires, the last in 1887. The canal was used to transport corrugated iron for its refit, but the business did not last.

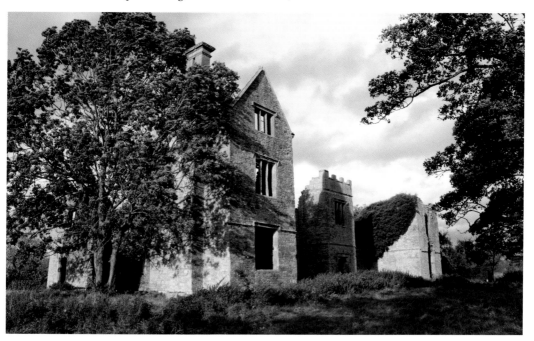

Oxford Cement Company

Enslow's wharf was of a different character. It served the remote Oxford Cement Company's works, which had no rail or road access – narrowboats brought coal, sand and gypsum down to the works and then trans-shipped the cement to the railway station at Bletchingdon. The Rock of Gibraltar pub (*opposite page, bottom*) ran the stables for the horses, and for a time the publican Henry Baker housed the wharfinger for the Company, with a discount on the coal he used and sold.

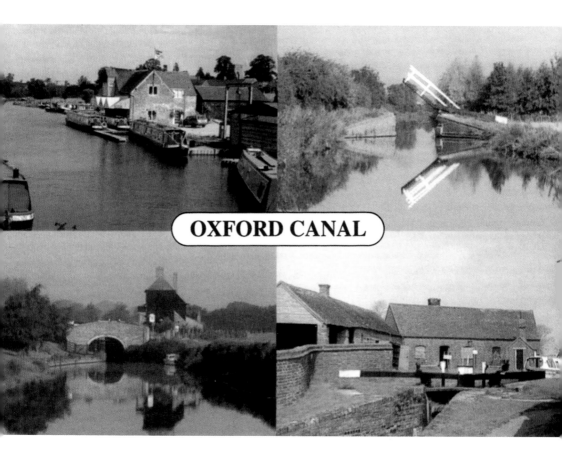

The Peaceful Oxford

This modern postcard gives an idea of the peaceful rural nature of the Oxford as it meanders through the Cherwell valley: top left, the wharf at Lower Heyford; bottom left, Somerton Top Lock; top right, lift-bridge at Aynho; bottom right, stables at Claydon Top Lock.

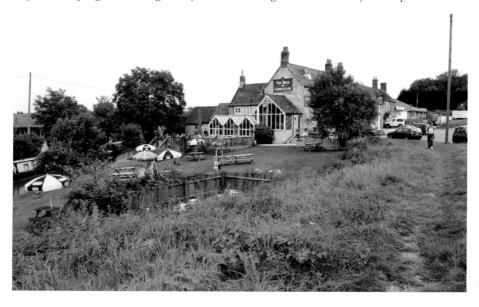

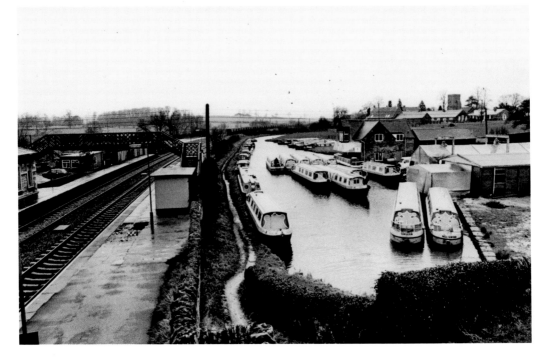

Heyford

Lower Heyford still presents a busy scene on the canal. Narrowboats have been built to order for 200 years here, and now they can be hired out. Heyford was something of a transport hub – the Oxford reached it in 1797 bringing coal from Leicester and Warwickshire, the Bicester–Enstone road became a turnpike road in 1798, with two toll-gates in the village, and the Oxford–Banbury railway (the GWR) opened a station here in 1850, which still operates on the line.

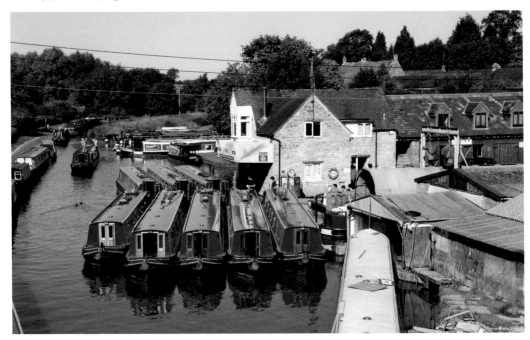

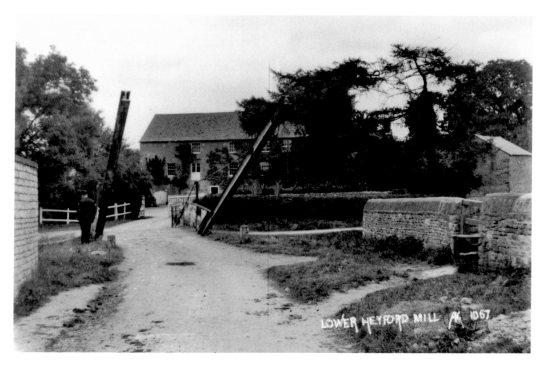

Milling at Heyford

Lower Heyford Mill is reached by its own lift-bridge over the canal; the first wooden bridge had to be rebuilt in iron to withstand a traction engine hauling the grain wagons over to the mill. Milling stopped in 1951 and the mill has now been converted to a house.

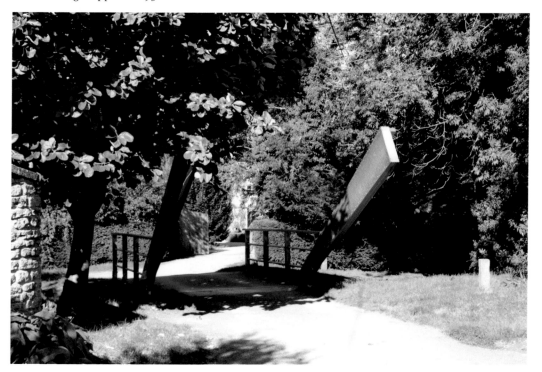

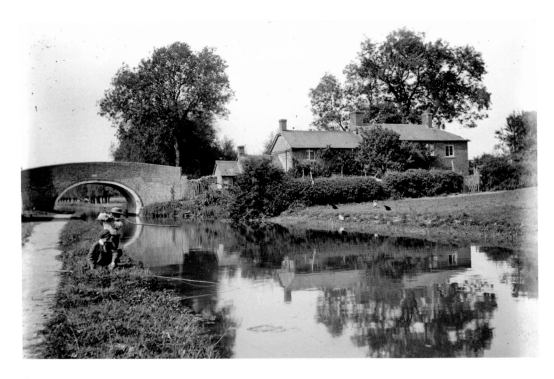

Somerton

Somerton village straddles an escarpment above the Cherwell valley, along which runs the canal. It was always a prosperous farming parish with ample meadowland in the river valley, which frequently flooded. The wharf and weighbridge were here by this bridge, but the locks lay to the north and south. These old cottages were taken down and rebuilt on a different alignment, facing the canal, around 2000.

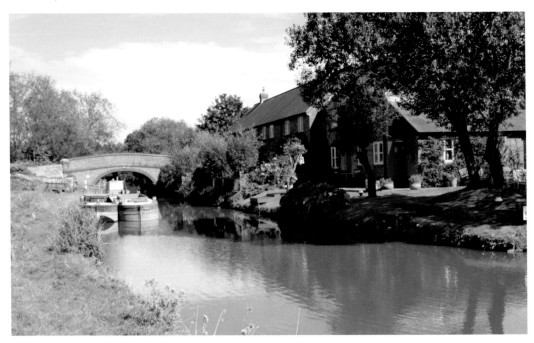

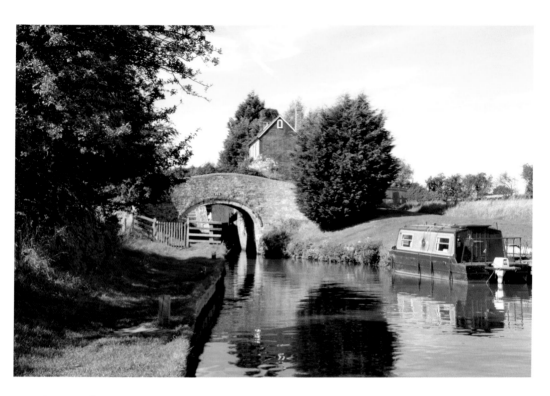

Deep Lock at Somerton

Somerton Deep Lock, superintended by this isolated lock-keeper's house, lies a good way north of the village and road bridge. The lock has a fall of 12 feet and it is constructed in a diamond shape so that the volume of water used was equal to that required at the next lock, for economy.

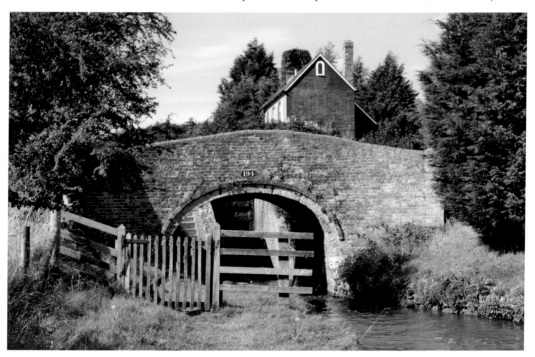

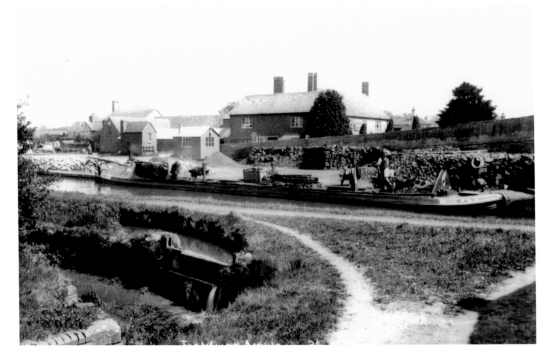

Aynho Wharf

Aynho Wharf on the main road to Deddington has a busy business hiring and servicing narrowboats. Its lock led off the River Cherwell with a small fall of only 8½ inches! The Oxford–Banbury railway runs alongside and the station dates from 1850, as presumably does the Great Western Arms pub (*inset*).

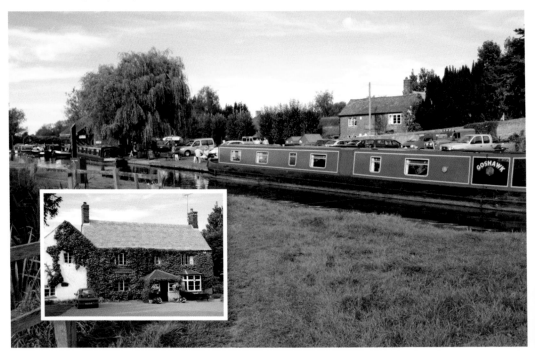

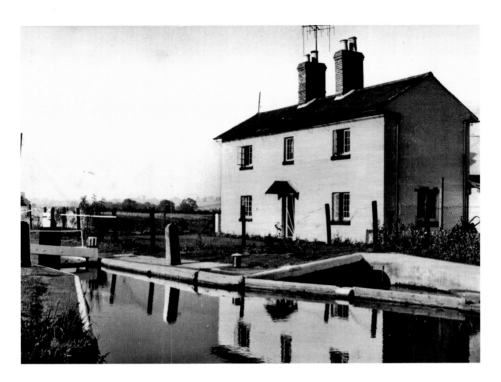

Nell Bridge Lock

Adderbury's Nell Bridge Lock is not far away. The wharf house was substantial and agreeable for the time. There was a cellar for coal which was cheaply garnered from the passing narrowboats. Ordinary water came from a pump primed by a bucket of canal water. There was a kitchen, store and granary, with the earth closet in the store. We skip Banbury, as that is another book altogether, but it is interesting to note that between Banbury and Oxford, a distance of 27½ miles, there were twenty-eight locks, thirty-eight lift-bridges, twenty-one wagon bridges of stone and twenty of brick.

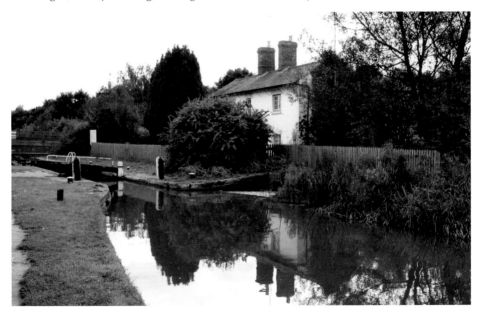

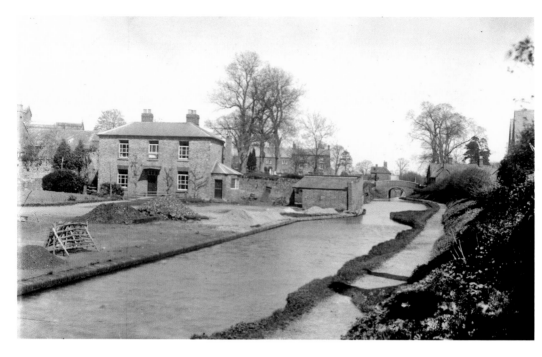

Cropredy

Cropredy's lock and wharf were for a short time the terminus of the Oxford when the canal reached it from Coventry in 1777, and the first coal-laden narrowboat arrived on 1 October. It has a pleasant wharf area and some surviving wharf buildings. The nearby rail station closed in 1956, but the canal traffic carries on!

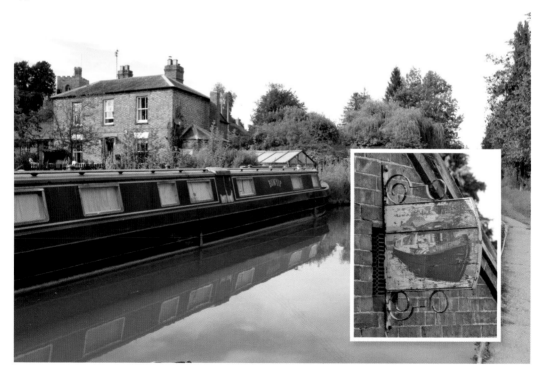

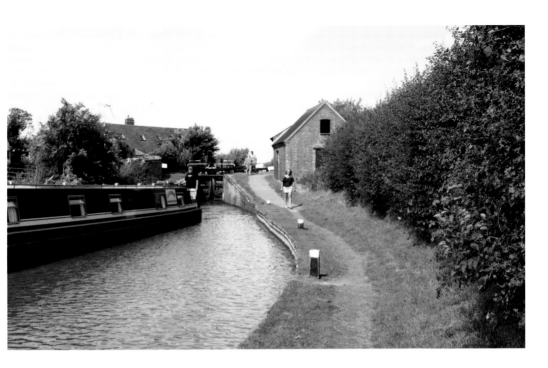

Claydon

At Claydon we reach the topmost point of the Oxford in Oxfordshire, a flight of five locks up to the summit of the canal at Claydon Top Lock, from where it begins the descent to Coventry. The water supply was ensured by two reservoirs, the Wormleighton and Clattercote, but there were still times when the supply was insufficient and a short canal arm to the river had to be constructed further along the summit at Napton. Water was then supplied by pump to the reservoir. Claydon's remaining wharf buildings are all at the deep Top Lock.

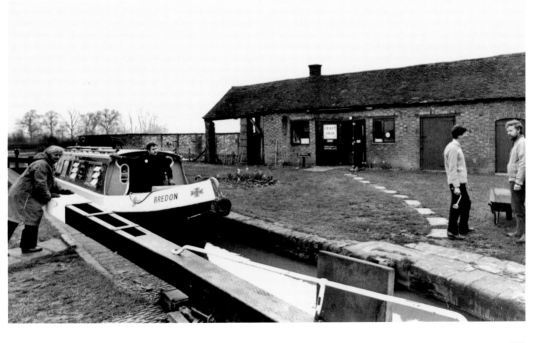

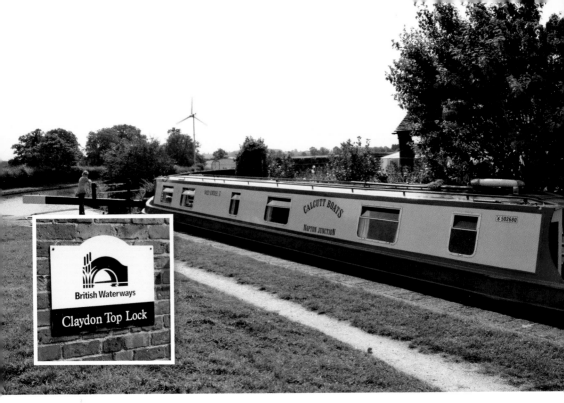